# A PHILOSOPHY OF INTERIOR DESIGN

# A PHILOSOPHY OF
# INTERIOR DESIGN

## STANLEY ABERCROMBIE

ICON EDITIONS

*1817*

HARPER & ROW, PUBLISHERS, New York
Grand Rapids, Philadelphia, St. Louis, San Francisco
London, Singapore, Sydney, Tokyo, Toronto

Grateful acknowledgment is made to the following for permission to quote from copyrighted material:

"Four Walls." Words and music by Willard Robison. © 1956 (Renewed) by Jewel Music Company, Inc. Reprinted by permission. All Rights Reserved.

"Design for Living." Words and music by Michael Flanders and Donald Swann. Copyright © 1977 by the Estate of Michael Flanders; Donald Swann. Reprinted by permission. All Rights Reserved.

FIRST EDITION

Designed by Karen Savary

Library of Congress Cataloging-in-Publication Data
Abercrombie, Stanley.
    A Philosophy of Interior Design / by Stanley Abercrombie.—1st. ed.
        p.   cm.—(Icon Editions)
    Bibliography: p.
    Includes index.
    ISBN 0-06-430296-2
    ISBN 0-06-430194-X(pbk.)
    1. Interior decoration—philosophy.   I. Title.
NK2113.A24   1990                                                    89-45506
729—DC20

90  91  92  93  94   DT/MPC  10  9  8  7  6  5  4  3  2  1
90  91  92  93  94   DT/MPC  10  9  8  7  6  5  4  3  2  1

*For the wonderful Ann Wilson*

with thanks to the designers and photographers
whose work is shown here

with thanks to Peter Shaffer and Monica Geran,
who read the manuscript

and with thanks also to
Dorothy Alexander, Alison Bond, Cass Canfield, Jr.,
George Cserna, David De Long,
Alberto Paolo Gavasci, Elizabeth Gordon,
Franca Santi Gualteri, Edward Frank,
Jack Hedrich of Hedrich-Blessing, David Lance,
C. Ford Peatross of the Library of Congress,
Erica Stoller of ESTO, W. Waldorf (for her comments),
and John Whiteman

# Contents

# Preface

Were it not so clumsy, the proper title for this book would be *Notes to Help the Interior Designer Form a Philosophy*, for it is not the goal here to prescribe a single comprehensive and universally applicable philosophy for all. Rather, the intent is to look at the elements of interior design in a way that might aid interior designers in the formulation of individual philosophies for their own work.

Ideally such a formulation occurs at the beginning of the practice of design, and so an ideal reader for this book is the design student. In practice, however, some designers work for years or even for whole careers without bothering about a philosophy, so perhaps some of the contents will be of interest to more experienced readers as well.

This book had its origin at a 1987 debate about interior designer licensing. My friend James Stewart Polshek, who was then dean of the School of Architecture and Planning at Columbia University and who was opposed to such licensing, argued that interior design could not be considered a true profession because it lacked a body of theory. This seemed an astonishing and dismaying idea at the time. I wondered if it could be true and thought that, if it were not, Polshek's statement should be refuted. Here, then, is an attempt at refutation.

Bodies of theory are in themselves dry, academic, and of debatable importance to practitioners, but they cannot exist without something that is of undeniable importance: the practice of thinking philosophically—that is, thinking in ways not overtly technical or pragmatic—about an area of endeavor. If interior design were new among mankind's interests, it could be that such thought had not had time to develop, but that is not the case.

ix

Interior design is one of our most venerable concerns. According to Exodus 27:16, even God practiced it, advising Moses: "And for the gate of the court shall be an hanging of twenty cubits, of blue, and purple, and scarlet, and fine twined linen, wrought with needlework." Before that, there was a time when interior design was being practiced and architecture was not yet imagined, our rough kinsmen painting the walls of their caves and furnishing them with comfortable pelts and clay vessels long before they began to construct freestanding buildings. Once they did begin, their plans for constructions were naturally whole: the structure and the space it housed were considered together, and this entity came to be known as architecture. Interior design was a basic part of it from the beginning, as was structural design.

Now that interior design has developed into an independent discipline with its own educational standards and curricula, its own professional organizations and publications and legal recognition, we find a need to isolate its philosophy, and it is largely the venerable body of writings about architecture, where philosophical thinking about interior design has long been subsumed, to which we look. But we can also look to less specialized literature—to general philosophy, to social studies, and even to fiction. For in all our civilized history we have been mindful of our rooms and our furniture and curious about their influences on our actions, our thoughts, and our emotions.

This book is therefore not a presentation of the invention of interior design philosophy, but simply a reminder of philosophical insights that have long existed.

# A PHILOSOPHY OF INTERIOR DESIGN

# BEING OUTSIDE

T O BE OUT IN THE WOODS, out in the fields, out on the seas, even out in the streets is to take chances, to subject ourselves to a realm not dependably dominated by human will. Accidents happen to us out of doors. There are bears, snakes, and runaway streetcars; there are uncharted paths with unpredictable turnings; there are strangers and no guarantee against their sudden appearance or irrational behavior. Outside, we are exposed.

In the wildest of circumstances, we are exposed to snow and hail, excessive heat and excessive cold. We are also psychologically exposed to the magnitude of nature, its amazing, sometimes terrifying abundance, multifariousness and age, a profligacy from which we—who like to think of ourselves as refined singularities—have inexplicably emerged. It is an exposure without which human experience would be incomplete, but it is exposure that most of us crave only in measured doses.

In the least wild of exterior circumstances, in the heart of a large city, we are exposed to a magnitude that can be even more frightening. Cities, long-established ones at least, are our most dramatic manifestations of the age of civilization, which, for humans, is likely to be much more poignant than the age of the universe. In a city like Rome or Istanbul, Cairo or Bangkok, we trace the progress (or decline) of man in the erected obelisks, the outgrown city walls, the crumbling forts, the canals that have become roadbeds. We see history in the cobblestones. Even in a relatively new city like Houston or San Diego,

1

there is an overwhelming amount of information in the physical evidence we see, information about physics, economics, merchandising, social classes and cultural habits. No city is a steady, complete or fully controlled entity; at every turn we are presented with contrasts and comparisons.

Between these extremes of wild nature and urbanity are all those circumstances where the efforts of man and nature combine. The earliest human environment, we are told, was a garden, and a garden is still a particularly inviting and provocative place. Unenclosed as it may be, it shares many features of habitable interiors. Its paths and trees are—at once almost literally and quite metaphorically—corridors and pieces of furniture, its lawns are carpets, its shrubs decor, its terraces salons. Its principles of composition, too, are really the same: axes, closures, destinations. Similar, too, the resultant effects: separation, discovery, transition, resolution.

There is also apparent in the garden a struggle for dominance of effect that is parallel to the struggle in designed interiors: in the case of the garden, competition between the will of man to impose a plan and the efforts of nature to blur the edges, overgrow the boundaries, obscure the order; in the case of the interior, competition between the designer and the occupant, even when these are the same person.

The student of interior design can learn from gardens, sometimes the indirect approach to a subject by way of reference and correspondence reveals something a more straightforward encounter does not. But the garden can teach us nothing about the most essential fact of the interior, its unmatched power over our state of mind. For all its delights and strengths, the garden, like the wilderness and the city, is missing a key dimension—*it has no cover*—and thus it can never be more than an echo of an interior.

Although many a history of architecture has been illustrated solely with photographs of building exteriors, it is rare that great buildings of the past have lacked great interiors. The pyramids of Egypt are the most obvious examples of those that do, yet even in those cases their burial chambers, while physically insignificant, had a psychological significance fully equal to that of their massive housings. In the age of skyscrapers, admittedly, many towers are noteworthy only for their profile and skin; inside, they are tray on tray of undistinguished, indistinguishable office space. Yet, despite the relative poverty of expression that marks the modern commercial interior, we know from experience that interiors have a power over us that facades can never

have. This is not due to the commonly observed fact that we spend most of our time indoors; it is due instead to the fact that interiors surround us. We do not merely pass them on the street; we inhabit them. When we enter a building, we cease being merely its observer; we become its content. We never fully know a building until we enter it.

The garden, then, can be highly suggestive, but it is never quite the real article. As in the wilderness or in the city, we are not sheltered there, nor safe nor in control. Let us go inside.

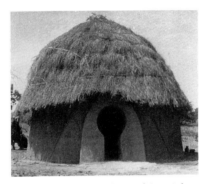

**Keyhole-shaped entrance of a Masai hut, Africa.** *(Photograph: Mouli-nard, courtesy Musée de l'Homme, Paris)*

# COMING INSIDE

ALTHOUGH OUR FIRST ENCOUNTER of any interior is the result of an entrance into it, a movement from outside to inside, our earlier and more fundamental experience is of movement from inside to outside, of a sheltered life before we knew an exposed one, for we were all—there can be few exceptions to this—born inside, were babies inside, became our recognizable selves inside a psychologically crucial container. Whatever the nature of this first environment, it was, by definition, residential; before we knew any other space, we lived there. However strong our later interest in spaces for commerce or public affairs, for banking or sports or theater, our feelings for these nonresidential interiors will inevitably be colored by our first interior experience, the residential one, to which, in memory or in daydreams or even, often, in our subconscious, we return all our lives.

It is from our impressions of this experience—the coziness of our own room or, lacking that, our own private spot in a favorite corner or the special world beneath the piano, the bustle of the kitchen, the ritual of the dining room, the closed door of the parents' bedroom— that our understanding of the effects of interior spaces of all types and functions has grown. This is not the right place nor, certainly, the right author for a weighing of the effects of environment against the effects of heredity, but none of us is without the lessons of youth. Entering an interior, therefore, is, to some small degree, always going home.

The particular point of entrance into an interior space, whether

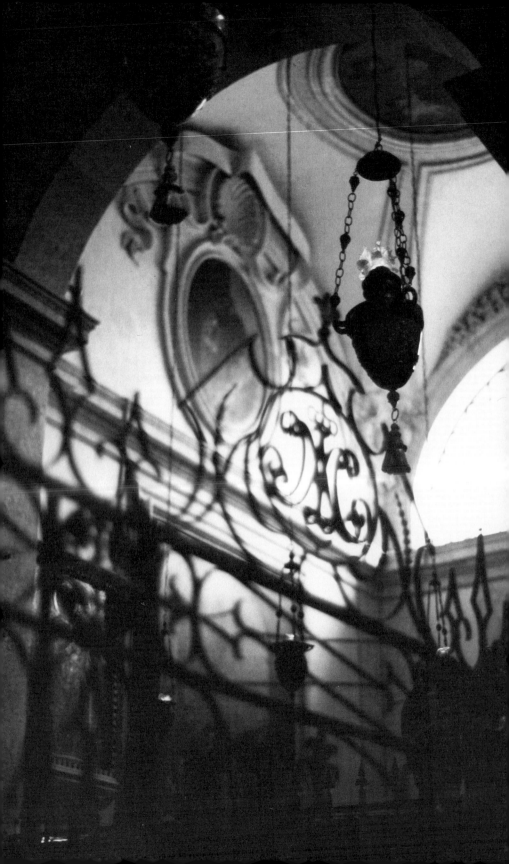

directly from the outside or simply from a corridor or elevator lobby, is a critical point in our appreciation of that space. It occurs at a boundary, and our entering crosses that boundary. Robert Venturi, in *Complexity and Contradiction in Architecture*, finds the foundation of architecture at this junction: "Designing from the outside in, as well as the inside out, creates necessary tensions, which help make architecture. Since the inside is different from the outside, the wall— the point of change—becomes an architectural event. Architecture occurs at the meeting of interior and exterior forces of use and space."

An entrance is a physical transition point, obviously, and also a mental one, the entrant bringing into the interior memories of the exterior and expectations based on those memories. An entrance is also a place of psychological significance. Adrian Stokes wrote in a 1963 essay that "in the fascination of gazing . . . into the outside light that invades an entrance, in a subject not uncommon for seventeenth-century Dutch painters, we may become aware that we contemplate, under an image of dark, calm enclosure and of seeping light the traumatic struggles that accompany our entry and our exit, in birth and death." And Porphyrus wrote in the third century, "A threshold is a sacred thing."

Crossing this sacred place and entering an interior dominated by others can be an anxious experience. The entrance is also the point within an interior where inhabitants feel most exposed to the uncertainties of the outside world. Hence our common desire for some shielding inside the door. Admittedly, this is a desire that, although typical for Western societies, is not universal. According to Jon Lang, a leader in applying behavioral science to the environment, "The point at which the occupant of a house is aroused by the approach of a stranger varies from culture to culture. In the traditional Islamic dwelling it occurs at the entrance from the street. In this case there is no semipublic or semiprivate territory. The transition is from public to private."

In our own culture, rather than plunge directly into the heart of an interior, into its living room full of conversation (as is unfortunately the pattern in many city apartments) or into its major work-

Adrian Stokes has written that in "the fascination of gazing . . . into the outside light that invades an entrance . . . we contemplate under an image of dark, calm enclosure and of seeping light, the traumatic struggles that accompany our entry and our exit, in birth and death." *(Photograph: author)*

The act of entering can make the entrant feel anxious and vulnerable, as in Gaetano Pesce's 1972 "Environment for Two Persons: Subterranean City." *(Courtesy Gaetano Pesce)*

room full of professionals at their desks, we prefer some transitional area where those already inside can screen those seeking entrance and where those entering can prepare themselves for the experience beyond. Although Thoreau, in his cabin at Walden Pond, a man radically austere in his domestic tastes, preferred "a house which you have got into when you have opened the outside door, and the ceremony is over," most of us would share the affection Le Corbusier expressed in

In this plan of a Lapp tent interior, one of the roles performed by the entrance foyer or reception room in more conventional buildings—the role of protection from unexpected visitors—is performed by the two dogs tied near the entrance flap. *(Courtesy Musée de l'Homme, Paris)*

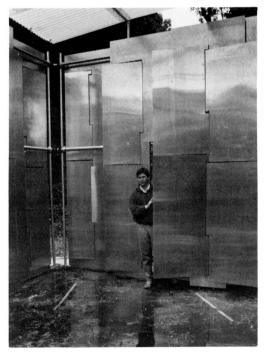

Entering an enclosure has psychological significance, as is manifest in moving through hinged aluminum panels into a pavilion designed by John Whiteman and built in Vienna in 1988. *("Divisible by 2," a project for the Chicago Institute for Architecture and Urbanism, the Skidmore, Owings & Merrill Foundation. Photograph: John Whiteman)*

*Towards a New Architecture* for "the little vestibule that frees your mind from the street."

The design of an entrance also serves in providing specific identification. For example: "Out of the clatter of the swarming street, which is for every man . . . , you have entered the house of a *Roman.*" And here, of course, we are at the heart of the significance of the entrance area: its role as introduction to the spaces beyond. It is the entrant's first impression of those spaces.

To properly design an entrance, therefore, one must already have conceived the quality of the whole interior. This is the designer's true entering into any design problem: his conceptualization of the desired result, not part by part, but overall. Like the foyer, vestibule or reception room of an installation, the design concept opens the way to all that follows, and the basic disclosure of that concept is by means of the plan, whether drawn or merely imagined.

# THE PLAN

FOR THE INTERIOR DESIGNER (and for the thoughtful architect, as well) the plan conveys not just the disposition of walls and openings but also of the furnishings within those walls and, by implication, even the character of ornament and accessories; it is the overview of the entire result. "The plan is the generator," Le Corbusier wrote in *Towards a New Architecture*. "Without plan there can be neither grandeur of aim and expression, nor rhythm, nor mass, nor coherence. . . . A plan calls for the most active imagination. It calls for the most severe discipline also. The plan is what determines everything; it is the decisive moment."

What are the sources on which the designer's plan is to be based? It must have its foundation in two considerations, and the first of these is the determination of limits. This determination must originate with the building shell, the character of its structure and the time and funds with which the designer must work. Presented with an apartment layout and a tight budget, for example, the designer may well conclude that each existing room must remain in its present form; the work will necessarily be limited to surface treatments and furniture selection, for there will be no opportunity for removing old walls and constructing new ones. With more generous working conditions, however, the designer's scope of work may stretch from one apartment wall to the other, a space interrupted only by structural columns and mechanical and plumbing lines that, continuing to other

apartments on other floors, cannot be moved without extraordinary expense.

The other fundamental consideration in the conception of a plan is function. It is a consideration that reached a mature level surprisingly late in the history of interiors. Historian Fernand Braudel points out that "when Louis XIV himself, in his palace at Versailles, wanted to visit Madame de Montespan, he had to go through the bedroom of Mademoiselle de la Vallière, the previous royal favourite." He also quotes the Princess Palatine as recording on a February day in 1695 that in the same palace "at the king's table the wine and water froze in the glasses."

By today's standards of comfort and convenience, however, successful design must be informed by the functions it is to house. One appealing expression of this informing is Mother Ann Lee's Shaker dictum that "every force evolves a form" and that a beautiful form is simply "the best response to the forces calling it into being."

The most familiar and most terse expression of this idea, of course, is Louis Sullivan's aphorism "form follows function," by which he meant, Frank Lloyd Wright explained, that form and function should be considered identical. Sullivan's own explanation, in *The Autobiography of an Idea*, is in the form of a comparison with nature: "And amid the immense number and variety of living forms, [I] noted that invariably the form expressed the function, as, for instance, the oak tree expressed the function oak, the pine tree the

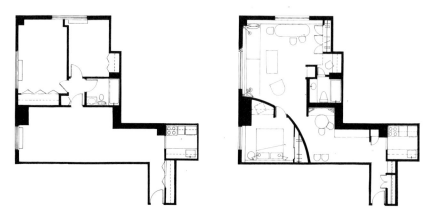

"Before" and "after" plans of an apartment remodeling by the New York design firm Lembo-Bohn show a radical alteration of the location of interior partitions. This degree of change is not always within the designer's province, of course. *(Courtesy Lembo-Bohn)*

function pine, and so on through the amazing series. And, inquiring more deeply, [I] discovered that in truth it was not simply a matter of form expressing function, but the vital idea was this: that the function *created* or organized its form."

Sullivan goes on to say that "this idea threw a vast light upon all things within the universe," but, for most of us, it is somewhat less illuminating, and the parallel between design in nature and design by humans is not particularly helpful.

We must also be wary of attempts to relate function and aesthetics, as in Horatio Greenough's admittedly appealing definition of beauty as "the promise of function." This relationship is one to which many designers have paid lip service, but one that is seldom the basis of actual practice. Even at the Bauhaus, the preeminent school of modern design, it was only during the brief (1928–30) directorship of Hannes Meyer, not during the more famous reigns of Walter Gropius and Ludwig Mies van der Rohe, that the accommodation of function became a pedagogical imperative.

It remains clear, though, that function, however little it may be identifiable with either nature or beauty, is a factor the designer must accommodate. The intended function of a room will naturally dictate the relationship between the room and the furniture in it and, at a later stage, also dictate the appropriate furniture choices. Will there be dancing in the center of the space or dining? Quiet conversations or weight lifting? Reception ceremonies or medical examinations? Many functions immediately narrow the designer's options.

Clients' functional requirements will sometimes be at odds with the character of the available space, of course. In these cases, the designer who is really conscientious will see the problem and make certain that the client sees it too; a "grand ballroom" can never be genuinely grand, the client must be told, with a nine-foot ceiling height. (The designer who is both conscientious and wise will put such objections in writing.)

An indication of the relationship of furniture plan to function is found in an essay by John N. Hazard that suggests that much can be learned about the judicial systems of different countries simply by studying courtroom furniture—the separations between judge, jury members, and the accused, the placements and sizes and varying heights of their chairs, the accommodations for members of the press. "Walk into an empty courtroom and look around," Hazard says. "The furniture arrangement will tell you at a glance who has what authority."

At times the character of the room itself will be the chief design determinant of its plan. A spectacular view through one particular window will draw comfortable seating around it, as will also a fireplace. And if it has been decided that a room will reproduce interior design of a particular period, that decision may affect the furniture plan, for the history of design is not just the record of stylistic changes within chairs and chests and tables, but also the record of how such pieces were placed. An important medieval room, for example, would have been very sparsely furnished by our standards, a room of the seventeenth century might have been furnished only around the perimeter, and a modern room might be furnished everywhere *but* the perimeter.

The designer should remember that any interior is possessed of more than practical functions; there are psychological, symbolic and narrative functions as well. These qualities have always been recognized by the best designers, even by such supposed arch-functionalists as Le Corbusier and Mies van der Rohe. Here is Mies, for example, writing in 1958: "Architecture depends on facts, but its real field of activity is in the realm of significance." And Le Corbusier in 1927: "My house is practical. I thank you, as I might thank Railway engineers, or the Telephone service. You have not touched my heart. But suppose that walls rise towards heaven in such a way that I am moved. I perceive your intentions. . . . By the use of raw materials and *starting from* conditions more or less utilitarian, you have established certain relationships which have aroused my emotions. This is Architecture."

And interior design as well. So the utilitarian conditions, while certainly determinants of any satisfactory plan, are only the starting points for that plan. What further considerations are there? Many of them, even though subjective, arise from the purely functional, for function not only demands specific quantitative responses but also suggests qualitative ones. A restaurant may need to seat a hundred patrons in a given area and may need a direct link between kitchen and dining areas, but its function also implies an appropriate lighting level, sound level and general appearance. The designer should ask of any installation if it should be commodious or cozy, specific or general, disciplined or relaxed, if it should be serene, dim and contempla-

In a courtroom, according to John N. Hazard, "the furniture arrangement will tell you . . . who has what authority." In the Lavaca County Courthouse, Halletsville, Texas, a raised and railed platform gives importance to the seats for the jury. *(Photograph: Geoff Winningham, courtesy Library of Congress)*

tive or bright and stimulating. Or, on a large and complex job, if it should offer a combination of several of these qualities.

Some environmental psychologists rate interiors according to their so-called information rate—that is, according to the amount of stimuli that the inhabitant is given to consider. On this scale, environments that are varied, complex, crowded, dense, unfamiliar or novel are said to be *high-load;* situations quieter, simpler or more familiar are called *low-load.* It is obvious that too much stimulation in an interior can overload its users, causing them confusion or frustration. Less obvious are the psychologists' findings that too little stimulation can also have ill effects. They report that windowless classrooms have more student absenteeism than those with windows, for example, and that the bare environment of a prison dampens mental activity. (Robert Sommer's *Tight Spaces* quotes one prisoner: "The thought of leaving prison a well-read man was smugly satisfying. Then I discovered that reading—reading intelligently—in prison is not easy, because one of the most difficult things to do in prison is to concentrate.")

This manner of looking at a plan may at times be a productive one for the interior designer as well. The designer need not be burdened with the psychologists' academic paraphernalia—charts, specialized jargon and even mathematical formulas—to be well served by the awareness that some functions call for high-load spaces, others low-load, and to design accordingly.

Other terms from the field of environmental psychology include *pleasure, arousal, approach, avoidance* and *dominance.* The questions they suggest about the designs we create are obvious but fundamental ones. For example, what degrees of pleasure or arousal are desirable in a board room, a library reading carrel, a theater lobby, a child's bedroom? And then the subsequent set of questions: What sorts of designs will offer these desired qualities? Such considerations can be applied at many levels, not only to the overall plan but also to particular rooms, to furniture groupings, to fabric selection and cabinetwork details.

There is clearly a danger in being unnecessarily pedantic about an aspect of design that is often considered instantly and without deliberation. Yet a little more deliberation about stimulation levels might save us from some of the most dreary of our current interiors. The typical general office area, for instance, with repeated rows of partition-hung office systems, all identically sized, identically colored and identically configured, often placed far from the pleasant distrac-

tions of outside views, presents the office worker with a mind-numbing degree of uniformity. What is wanted is not just more variety of physical equipment and surface finishes but also a recognition that the human animal is adaptable to—and often craves—variety in light levels, variety in sound levels and sometimes even variety in temperature. The desperate efforts at cubicle personalization that occur in most offices are eloquent testimony to design failure, and the frequency of workers' visits to the coffee urn or the water fountain is probably attributable to environmental ennui more than to thirst.

Plans come in many varieties, of course. One way to characterize different types of planning is to consider the type of movement they promote or allow. Although classifications of any subject so broad are necessarily arbitrary, it may be useful to distinguish three basic plan types relative to movement.

First, plans càn *direct* linear movement toward a goal, such as toward the altar in a basilica-type church, or, as in an Egyptian temple, toward progressively sacred precincts, or, as in a traditional Chinese house, from public toward increasingly private spaces. Such plans need not be axial or symmetrical, of course, nor must the directed movement begin at an extreme end or proceed in a straight line. The circulation in Alvar Aalto's Baker House dormitory at the Massachusetts Institute of Technology is quite clearly directed by the plan, however sinuous the overall form.

Second, plans can *focus* movement from many directions on a central space, activity or form. Many centralized religious structures share this sort of organization; for example, the Roman Pantheon, a

A plan that directs movement: Aalto's Baker House dormitory, Massachusetts Institute of Technology, Cambridge.

stupa in Nepal and Louis Kahn's preliminary design for a Unitarian church in Rochester. This plan type can also be secular, as in Vignola's cortile-centered Villa Farnese at Caprarola.

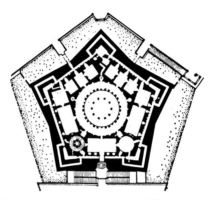

**A plan that focuses movement: Vignola's Villa Farnese, Caprarola.**

Third, plans can *free* movement to find its own pattern. This plan type, like the others, is venerable, examples including the Greek agora and the Roman forum, but it is also much used in our own time, for railroad concourses, market halls, convention exhibition halls and other large structures. Another type of free plan is used in the traditional Japanese house—free, in this case, because of its flexibility, its enclosures determined by movable *shoji* and *fusuma*, and free also in a temporal sense: what had been a space for dining during the day may well become a space for sleeping in the evening.

**A plan that frees movement: Mies van der Rohe's Crown Hall, Chicago.**

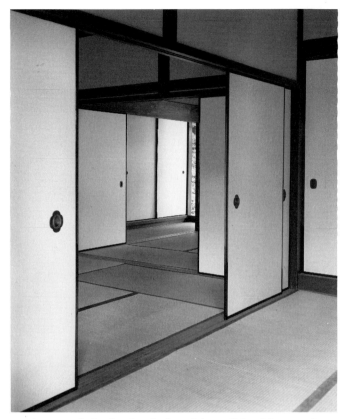

Another type of plan freedom is that of the traditional Japanese house, its spaces opening to one another by the manipulation of *fusuma*, sliding wood-framed panels. *(Photograph: Norman F. Carver, Jr.)*

All three plan types and their myriad combinations and variations have recurred throughout history, but the last type, under the name *open planning*, has been particularly identified with our own time. Although the notion of universal space is said to have first been presented visually in Renaissance painting, the plan that represents this notion in three dimensions has become dominant only in this century. Since its advent, in fact, a new question has arisen to face the designer: To what degree shall there *be* rooms?

Sigfried Giedion, the chief historian of the modern movement in architecture and design, related the open plan to Cubist painting. In his Charles Eliot Norton lectures at Harvard in 1938, later published under the title *Space, Time and Architecture,* he stated: "Around 1910 Picasso and Braque, as the consequence of a new conception of space, exhibited the interiors and exteriors of objects simultaneously. In architecture Le Corbusier developed, on the same principle, the inter-

penetration of inner and outer space." This interpenetration, he continued, was observed in the seventeenth-century buildings of Borromini, but "could have further development only in an age whose science and art both perceived space as essentially many-sided and relational."

Similarly, Alexander Dorner, in *The Way Beyond Art,* 1958, expressed the prevalent view of the time that modern architecture and interior design were results of a confrontation between function and form. "In the struggle between the autonomy of functionalism and that of form," he wrote, "the latter was bound to be the loser. . . . Walls and furniture became self-changing; spaces interpenetrated, discarding, as in abstract painting, space as the standard of reality; the dissolution of walls into glass eliminated the static opposition of inside and outside space and multiplied the functions of space, exploding it. . . . The building was no longer 'beautiful' . . . for the truly revolutionary energies of modern architecture must now be evaluated according to their life-improving efficacy."

Thirty years later, of course, we see these views of modernism— as being inevitable, revolutionary and unprecedentedly functional—as a delusion, and we see the open plan, therefore, not as a triumph of function over form but simply as the manifestation of a dramatic change in taste. Even so, because the designer needs to be familiar with such changes, the free plan needs a bit more attention than the

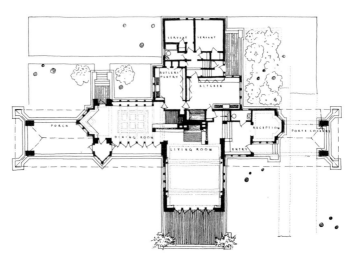

Wright's version of an open plan, centered on a fireplace core: the Ward Willitts house, Highland Park, Illinois, 1902.

other two general plan types so that we are well aware of its nature. The surprising variability of that nature can be demonstrated by comparing those plans employed by the three modern masters, Frank Lloyd Wright, Ludwig Mies van der Rohe and Le Corbusier; each had his distinctive version of the free plan and each his characteristic version of furniture placement for it.

Wright characterized his struggles away from the closed rooms of traditional plans as an effort to be free of being "boxed, crated," and said he "first *consciously* began to try to beat the box in the Larkin Building—1904." In that office building, in his Unity Temple two years later, in the Johnson Wax headquarters of 1939 and, most dramatically of all, in the Guggenheim Museum at the end of his career, he indeed broke away from the planning of conventional enclosures. "Scores of doors disappeared," Wright wrote in 1931, recalling his earlier work, "and no end of partition. . . . The house became more free as 'space' and more livable, too. Interior spaciousness began to dawn."

Yet in most of his residential work, his open plans retain some element of the plan type that focuses movement rather than frees it. The object of this focus, typically, is a fireplace or cluster of fireplaces at the heart of the house, around which spaces and partitions are spun in delightful freedom but toward which attention always is drawn back. (He wrote, in *The Natural House,* of "the fire, burning deep in the solid masonry.") If one wanted to kill one of these houses, one would know exactly where to shoot. And, as if thrown against the walls by centrifugal force, the furniture in the Wrightian interior is largely attached to the structure, as much a part of the architecture as could be made practical. ("The most satisfactory apartments," Wright had written as a young designer, "are those in which most or all of the furniture is built-in as part of the original scheme considering the whole as a unit.")

The free plan of Mies is very different. It seems to exist in a powerful magnetic field, the magnetism keeping the walls suspended in a tense configuration that prevents their ever touching. Furniture, too, is caught in the field, pulled away both from the solid partitions that modulate the space and from the glass line that forms a climatic but not a visual boundary. Beyond that glass line, wall, roof and floor planes may extend into surroundings that are imagined as uniform and limitless. The Miesian plan is open not just from area to area but, philosophically at least, to the universe.

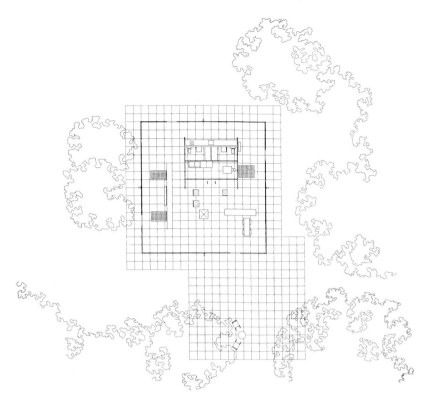

**Another open plan by Mies van der Rohe, this one showing furniture kept characteristically free of the exterior walls: the Fifty-by-Fifty House project of 1951.**

The Corbusian free plan is open to the world outside primarily through horizontal ribbon windows, there being a palpable wall enclosing the interior. The world inside this wall is not part of the universe, as is Mies's world, nor part of the surrounding landscape, as is Wright's, but a hermetic domain of its own. Unlike Wright's plan, there is no center of gravity here; rather, all elements—walls, floors and ceilings, cabinets and doors, tables and chairs—are bound up in a three-dimensional composition that is thoroughly, idiosyncratically Corbusian. While the placement of these elements is, as Le Corbusier advertised, free of the building structure, his *plan libre* is not as radically open as that of Mies. As Edward Frank has written, "It is not in Le Corbusier's protocol to deny the uniqueness of human space with the sweeping employment of glass planes. Nor will he project cantilevered decks into the natural environment in the confident and generous gestures of Frank Lloyd Wright." Rather, Frank says, Le Corbusier shelters his interiors "as if there lingered the memory of ancient human vulnerabilities."

The fact that the free plan, with all its variations, has come into prominence in our own century does not, of course, mean that it is the best choice for all our designs; discrete rooms have always had value. In her first book, *The Decoration of Houses*, written in 1902 in collaboration with architect Ogden Codman, Jr., Edith Wharton seems to have anticipated with some apprehension the free plan's future popularity. "Whatever the uses of a room," she wrote, "they are seriously interfered with if it be not preserved as a small world by itself. If the drawing-room be a part of the hall and the library a part of the drawing-room, all three will be equally unfitted to serve their special purpose. The indifference to privacy which has sprung up in modern times, and which in France, for instance, has given rise to the grotesque conceit of putting sheets of plate-glass between two rooms, and of replacing doorways by openings fifteen feet wide, is of complex origin. It is probably due in part to the fact that many houses are built and decorated by people unfamiliar with the habits of those for whom they are building."

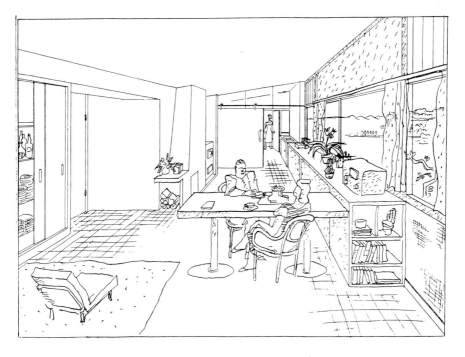

**An open plan interior envisioned by Le Corbusier: the Foreman's House Project of 1940.**

One more variant of the free plan that deserves specific mention and that, beginning in the 1960s, was seen for a while in the open planning of large office spaces was the picturesque, seemingly random furniture placement within those spaces advocated by a German design group called the Quickborner Team. This type of plan, called *Bürolandschaft,* or "office landscape," was based on actual working relationships among workers rather than on office hierarchy, and it offered an admirably varied, "high-load" environment. First seen as humorous or shocking, its seemingly random clusters of desks proved to have merits and gave rise to a whole industry of furniture that might be appropriately used in such a plan. It also proved to be less than ideally efficient in accommodating optimal numbers of workers, so that today "open-plan" furniture remains and is highly successful, but the "office landscape" is seldom seen.

An early example of *Bürolandschaft* in the United States was designed in 1967 as a test of efficiency for Du Pont, Wilmington, by the Quickborner Team from Germany. *(After John Pile, Open Office Planning)*

The Quickborner variation's rather radical reworking of the free plan reminds us, as do the variations in the work of the modern masters, that all plans of all types are subject to infinite variations, modifications and combinations. Malcolm Quantrill, in *The Environmental Memory*, has speculated what the Pompeiian house, its rooms axially ordered and focused on a central atrium (and therefore a combination of the plan type that directs and the one that focuses), might be like if it took on the distortions of Italian Mannerism. The result, he imagines, would make it hardly recognizable and would include an elliptical, rather than rectangular, atrium and a displacement of the axial movement straight through the center of the house by access from the corners of the plan.

There are many other ways of distinguishing different types of interiors and their plans, of course. In a 1968 book that intelligently reviewed recent public interiors in Britain, Hugh Casson classified the work into five "moods": idiosyncrasy, integrity, ceremony, geometry and fantasy. Giedion, in a more solemn and comprehensive effort, divided the history of all architecture into three reigning "space conceptions." The first, which he called "architecture as space-radiating volumes," he thought dominant during the first high civilizations of Mesopotamia and Egypt and ending with Greece. The second, "architecture as interior space," dominated Roman, medieval, Renaissance and baroque building. And the third, the conception of the twentieth century, is "architecture as both volume and interior space."

These categories may remind us that, basic as the plan is, it is only a two-dimensional representation of what will be a three-dimen-

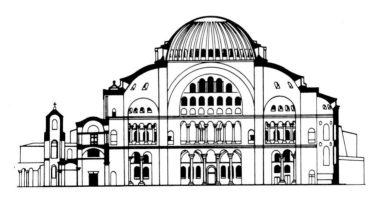

For some buildings, such as Istanbul's Hagia Sophia, a vertical section is more informative than a plan, but section and plan are intimately related.

sional interior. As the plan is devised, the designer must imagine it in the round, with the features of its layout augmented and emphasized by variations in ceiling height. In some designs, in fact (Hagia Sophia, for example), the floor plan itself is relatively mute about the nature of the interior, while the vertical section tells all. In the best designs it is rare that such vertical dramatics will not be related to events shown on the plan; we seldom put the skylight over the closet. As Le Corbusier expressed this principle, "The plan bears within itself a primary and predetermined rhythm: The work is developed in extent and in height following the prescription of the plan."

Just as plan and section should be considered together, both the fundamental planning considerations we have discussed—the determination of limits and the accommodation of physical and psychological function—should occupy the designer's mind simultaneously, for they are two coexistent problems that demand a single solution. It is best that the size, shape and character of a plan not be determined serially, with practical limits first dictating size and shape, and with subjective responses to imagined function later dictating character, but that all be determined together, for character is not separable from physical form but is governed by it.

The design process depends, then, in each case on a small miracle: the mental juggling of a number of interrelated determinants until, often at an unforeseen moment, the pieces all fall into place and a single concept evidences itself, fulfilling all requirements.

The truly inspired plan will more than fill requirements; it will move beyond those requirements to a whole new level of accomplishment; it will be more than a calculated sum of parts. As Piet Hein wrote in *The Architectural Forum* in 1967, "Art is solving problems that cannot be formulated before they can be solved. The shaping of the question is part of the answer. That is how the creative process works even in the most exact fields, just as it does in the recognized art forms."

This plan, however, for all its answering of unasked questions, can be a sketchy thing, a mere skeleton of an idea to be later fleshed out with all the details of lighting, art works, upholstery, ceiling profile and wood grain. It is best, indeed, if such details do follow the initial concept, for then they will be more likely to be guided by it. The idea first, however general; the execution later, however specific.

Obviously, you may say. Yet in practice the reverse is temptingly easy: easy to examine the client's budget first and, assuming the max-

imum allowed expenditure to be the best solution, let that budget determine at the outset the materials to be employed. A big budget? Then granite table tops, by all means, rosewood bases, glazed plaster walls. A tight budget? Then vinyl tile and painted Sheetrock. Physical objects dominate in such a process, and thoughtful concepts come, if at all, as their stepchildren.

Easy, too, for a designer to subordinate a plan to one particular client demand at the expense of other needs. Is a family heirloom—a pine breakfront, say—to be featured in a newly designed apartment? Then, the designer may say, we will begin there and build our design by surrounding the piece with complementary objects and materials. But a single piece of furniture is not properly a starting point if the total result is to be functional and aesthetically convincing; the designer needs first to determine a solution to all requirements, and that solution must be founded not on any object or group of objects, but on something quite subjective: an appropriate vision. This vision will then determine whether the breakfront is to be filled with books and used in a study corner or to be lined with shirred silk, filled with china and used in a dining area, or to have its doors flung wide to disclose a startling sculpture of stainless steel, or if its pine patina is to remain or be bleached back to its earlier, lighter color, or if the whole damned thing is to be enameled scarlet.

The importance of an initial concept cannot be overstressed. James Marston Fitch has quoted Austrian philosopher Ernst Fischer as saying that a good honeybee can put a bad architect to shame, but "what from the very first distinguishes the most incompetent of architects from the best of bees is that the architect has built a cell in his head before he constructs it in wax."

In conventional plans, rather than in open plans, it is by means of doors that we progress from room to room, or by means of passages and halls, which are really doorways thickened into small rooms. Rudolf Arnheim, in *The Power of the Center*, a book that divides the organization of all buildings (as well as all paintings and sculptures) into centric and eccentric types, suggests that occupants of rooms are at least subliminally aware of the central points around which all those rooms' features can be balanced. "As the spatial surrounding changes," he says, "so does its balancing center. When the space is continuous, as in a hallway, the center may move steadily with the viewer like a guiding star; when the space consists of a succession of detached rooms, what results is the more complicated experience of a

particular center approached, reached, overcome, and then replaced by the center of the next room."

In the same book Arnheim hints at the danger of considering organizational diagrams as fully developed plans. He quotes a Rosalind Krauss essay on "what happened when artists of our century began to paint grids." To paint such diagrams, Krauss thought, was to break thoroughly with the pictorial tradition, turning art into a "realm of exclusive visuality. . . . Never could exploration have chosen less fertile ground." Arnheim then asks: "If such schematic patterns are indispensable for the order and meaning of artistic composition, why do they tend to look deadly when they are used as compositions in their own right?"

His answer is that "since visual dynamics is the indispensable carrier of artistic expression, diagrammatically simple shapes are plagued by . . . poverty of expression. When art is kept free from schematic simplicity, it has many ways of generating expressive dynamics, through variations of shape, color, and relation." But this does not mean that an underlying organizational scheme will not strengthen art that is expressive. "Once alive," Arnheim continues, art "will profit rather than suffer from being organized by compositional patterns." Later he calls order "necessary to make an artistic statement readable," but the order should not be mistaken for the message that is to be read: "Order . . . is only a means to an end. By making the arrangement of shapes, colors and movements clear-cut, unambiguous, complete, and concentrated on the essentials, it organizes the form to fit the content. It is, first of all, the content to which composition refers."

Although interior design is overwhelmingly a matter of choosing and manipulating objects, that choice and that manipulation are, at best, directed by intelligent purpose. The good designer is not a slave to a chintz pattern or even to an open-plan office system. Although interior design is intensively a hands-on process—the designer needs to feel the wool, to sit in the chair, to see the paint chips in different lighting conditions—the most critical design work is totally abstract: the designer's role is not to build the design, to assemble it, to select it or to purchase it, but, first and primarily, to think it.

# ROOMS

"A PLAN," LOUIS KAHN SAID, "is a society of rooms." Having considered the physical and monetary restraints of a design problem, having considered also the physical and psychological functions to be accommodated, and then having satisfied these, however sketchily, in a conceptual plan, the designer is ready to consider the individual members of that "society": the rooms. This is a critical part of the design process.

Critical because, important as the overall plan is in guiding all that follows, the users of that plan will experience it room by room. A room presents our senses with limits, both visual and aural. There may be breaks in a room's enclosure by means of doors and windows, and, in the most open of planning, a room may only be implied by a few carefully placed screens and not enclosed at all; nevertheless, the room is the basic unit for our perception of a design.

It follows that the designer should give it unity. The concept for a group of rooms may very properly include variations and contrasts, but singular rooms should have cohesion. Not that there can be no surprises in them, certainly, but the best rooms leave us in no doubt about their character.

The first thing we perceive about a room, usually, is its size. We have learned as children—Piaget has outlined the process—to judge volumes of space, and this is what we do automatically and unconsciously whenever we enter a room. In the abstract, these volumes

29

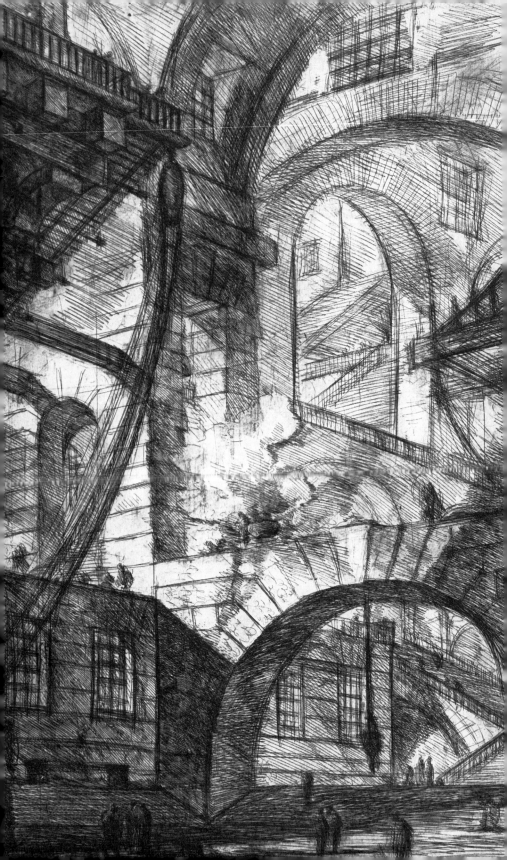

have no values; big is not better than small. But we never experience volume in the abstract, only in specific situations, and these situations need to be manipulated by the designer so that the perceived volume has the desired effect.

Large volumes of interior space, like the wide outdoors, can be liberating (*archy's life of mehitabel* speaks of "the great open spaces where cats are cats") or terrifying (the poet Charles Olson, in his study of *Moby Dick*, writes, "I take SPACE to be the central fact to man born in America, from Folsom Cave to now. I spell it large because it comes large here. Large and without mercy"). Piranesi's etchings of prisons show such terrors; in these vast halls one is deprived of all visual privacy, deprived, too, of sanctuary from the echoes of screams rolling through the stone vaults, and, as Marguerite Yourcenar has written, "This sense of total exposure, total insecurity, perhaps contributes more than all else to making these fantastic palaces into prisons." Contributing to the sense of insecurity is the architecture's incomprehensibility. What we see is a part—we cannot tell how large a part—of a great complex stretching not only far beyond our vision but also far beyond our reason. There is no logical order in what we see that would allow us to predict what lies beyond. Prison deprives us of control over our own condition; if we cannot understand our environment, we cannot control it. In Piranesi's unknowable spaces, we are lost.

Similarly, small spaces can be either claustrophobic or cozy. (Edgar Allan Poe, who has been called by art critic Walter Benjamin "the first physiognomist of the interior," wrote of "man caught in diminishing, malevolent space—the maelstrom, the closing room, the crowded street, the grave. Man lost in *constructions*." But "the smaller rooms," the half-human narrator of Kafka's "The Burrow" says, ". . . they enclose me more peacefully and warmly than a bird is enclosed in its nest.")

The one factor that man always considers in relationship to a volume of space is himself. We are all pretty much the same size, and it is that size against which we measure space. We also see similar distances and hear sounds in a similar range of volumes; we walk at about the same speed; we talk, sing, or shout at the same general level. We all know, intuitively, the room sizes appropriate for various

**Plate Six of Piranesi's *Carceri*: "total exposure, total insecurity."**

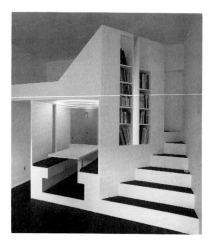

**Two views of a construction by George Ranalli. Within a larger room, it provides some intimate areas: a dining alcove below, a library/stair, and a sleeping loft above.** *(Photograph: George Cserna)*

human activities—the space needed for basketball games or for stock trading, the right size of opera house for the intimate charms of *Così fan tutte*, another size of opera house for *Aïda*, suitable rooms for dinner for eight, for conversation for two, for solitary study.

Of course, we all also share the qualities of flexibility and individuality. What suits one person may not suit the next, so that the fixing of ideal room sizes can never be exactly prescribed. Thoreau, for example, felt a highly unusual need for more space—rather than more intimacy—for talking with a friend: "One inconvenience I sometimes experienced in so small a house, is the difficulty of getting to a sufficient distance from my guest when we began to utter the big thoughts in big words. You want room for your thoughts to get into sailing trim and run a course or two before they make their port. . . . In my house we were so near that we could not begin to hear,—we could not speak low enough to be heard; as when you throw two stones into calm water so near that they break each other's undulations. . . . As the conversation began to assume a loftier and grander tone, we gradually shoved our chairs farther apart till they touched the wall in opposite corners, and then commonly there was not room enough." In any case, as Kahn put it, "in a small room one does not say what one would in a large room."

Most "societies" of rooms will need a variety of room sizes. We know that Renaissance princes liked to retreat from the great public rooms of their *palazzi* into more intimate *studioli*, which were both private and small. As Gaston Bachelard has written in *The Poetics of Space*, a work from which we will quote frequently here, "To sleep

well we do not need to sleep in a large room, and to work well we do not have to work in a den. But to dream of a poem, then write it, we need both. . . . Thus the dream house must possess every virtue. However spacious, it must also be a cottage, a dove-cote, a nest, a chrysalis. Intimacy needs the heart of a nest."

Sometimes the designer will have control over room size; sometimes not. Often ways must be found to divide a vast space into smaller, more easily comprehensible areas; often, too, ways must be found to make a too-small space tolerable.

One problem of room size in current practice is that of the large office. Influenced by the economics of real-estate development and space management, the typical office floor is open except for the service elements (elevators, fire stairs, toilets, mechanical shafts, etc.) at its core and is subdivided not by conventional walls (except for a few privileged executives) but by the movable panels of furniture "systems." This constitutes the reality of the workplace today. It also

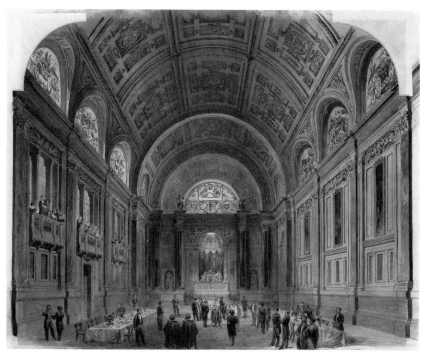

A vast but agreeable hall proposed by Penrose and Goodchild for the Worshipful Company of Grocers, London. *(Courtesy British Architectural Library/RIBA)*

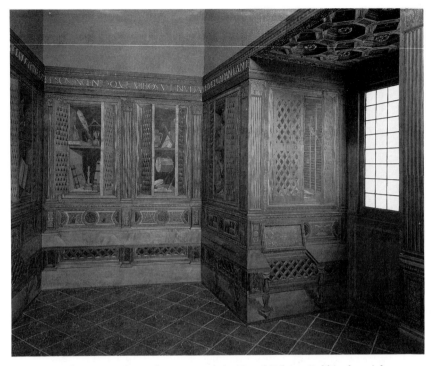

Small, compared to other rooms of the Ducal Palace, Gubbio, but rich with intarsia of walnut, oak, beech, rosewood and fruit woods: the fifteenth-century *studiolo* of Duke Federigo de Montefeltro, designed by Francesco di Giorgio of Siena. *(The Metropolitan Museum of Art, Rogers Fund, 1939)*

constitutes perhaps the most intractable problem now facing the interior designer, for, useful—indeed, it seems at the moment, irreplaceable—as these panel devices are, it is notoriously difficult to bring the virtues of the traditional room (unity, comprehensibility, an appropriate relationship to human size) either to the whole open floor of the office building, which is generally too big, or to the individual panel-bounded cell, which is too small. Serious thought needs to be given to providing some features at intermediate scale that can make this ubiquitous work environment a place of physical and psychological satisfaction.

Volume is only the most obvious characteristic of a room, of course. Even more telling, at times, is the distribution of that volume,

The Double Cube Room, Wilton House, Wiltshire, attributed to Inigo Jones and John Webb. It is 66 feet long, 33 feet wide and 33 feet high. *(Photograph: A. F. Kersting, London)*

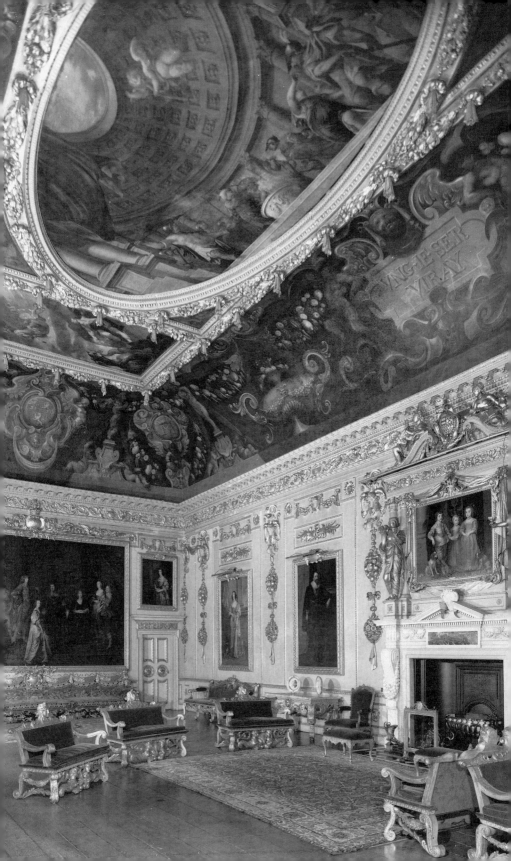

the room shape. We naturally judge whether or not a shape is suited to the functions it will house; further, we note whether or not a shape is, in itself, pleasing. Much time and effort has been spent theorizing about systems of proportion that will help the designer arrive at "ideal" relationships among the various dimensions of a room. Our poor abilities of perception, however, are so rough that some of this effort is wasted: a room with length/width/height relationships fairly close to those prescribed by Le Corbusier's "Modulor" proportioning system, for example, will satisfy most of us just as well as one with the exact relationships prescribed by the system, and the practiced designer will probably find intuitive judgment just as useful as mathematical calculation in determining room shapes.

There are, however, a few—a *very* few—geometric shapes that we can easily identify, and such identification often gives us pleasure. To be in a perfectly square room or a perfectly circular one is to feel the importance of being somewhere with equally important directions of approach and being therefore central. This reaction is even stronger when the shape is three-dimensional, as in the Domed Saloon of Lord Burlington's Chiswick House, which, below the dome, is an octagon filling a perfect cube, or in the famous Double Cube Room at Wilton, attributed to Inigo Jones and John Webb, or, most powerful of all, in the clearly implied sphere of the Roman Pantheon. These voids are the negative counterparts of the Platonic solids, forms so pure, Plato thought, that they existed independently of the world. But these few shapes practically exhaust the list of those we can detect. A triple cube room, for example, would be perceived merely as a long rectangular shape, unless there were some applied markings to identify three equal cubic divisions. And strong as the effect of simple geometric volumes may sometimes be, it would be difficult to prove that their power is greater than that of spaces—those of the Baroque period, for example —that are complex and irregular.

Nor is geometry ever satisfactory alone; in the "dynamic rivalry between house and universe," Bachelard points out, little importance attaches "to simple geometrical forms. A house that has been experienced is not an inert box. Inhabited space transcends geometrical space."

Beyond the basics of room size and room shape come other factors that contribute to room character. Most prominent among these are the surfaces that bound the room.

# ENCLOSING PLANES

ROOMS ARE ENCLOSED BY PLANES—floor, ceiling and walls. Due to the design of our own anatomy, which keeps our eyes most naturally facing straight ahead rather than up or down, the walls are the most prominent of these. Here are four (or, in unusual shapes, more or less) opportunities that demand design attention. It will often be the case, of course, that wall location will have been unalterably fixed before the designer begins work. But even then the designer may have the option of interposing new walls among the existing ones. Or partial walls: today's designer has received as an inheritance of open planning a new freedom from the rigid repetition of separate, closed, discrete rooms. Spaces can now be subdivided by an inexhaustible vocabulary of partial partitions and screening devices (among them, manufactured open-plan furniture systems) positioned and shaped in any way the designer devises.

One consideration that may influence wall treatment is whether or not the wall is clearly a load-bearing participant in the building's structural system or merely a partition; if the former, some appearance of substantiality may be appropriate. Even when the wall is free of any structural duty, the designer may want to consider its venerable history as an architectural element, this being a consideration particularly apt in traditional decor.

Specifically, the designer may consider the wall as an embodiment of the classical orders, those features of a system so venerable and widely used that, for Western man, it has become a common language.

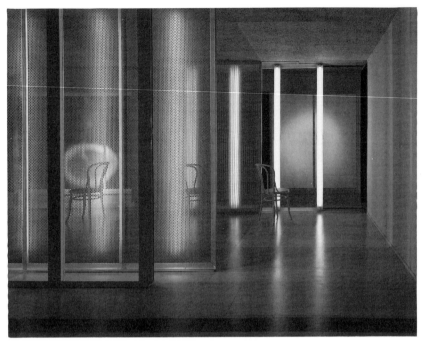

Walls are not necessarily "either/or." With semi-transparent screening effects, we can enjoy spatial division without complete visual interruption. Thonet showroom, Chicago, 1981, by Krueck & Olson. *(Photograph: Nick Merrick, courtesy Hedrich-Blessing)*

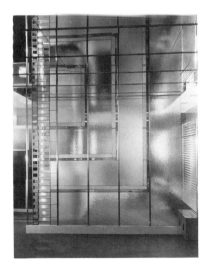

Another variation on the opaque wall: In a Libby-Owens-Ford showroom of 1938, glass planes obscure view yet transmit light; a mirrored ceiling enriches the effect. *(Photograph: Giovanni Suter, courtesy Hedrich-Blessing)*

According to Edith Wharton, "In all but the most cheaply constructed houses the interior walls are invariably treated as an order." Thus she likened baseboards to "the part of an order between shaft and floor" and cornices to "the crowning member of an order." The main feature of a classical order, she pointed out, is only implied: "It will be clear that the shaft, with its capital, has simply been omitted, or that the uniform wall-space between the base and cornice has been regarded as replacing it."

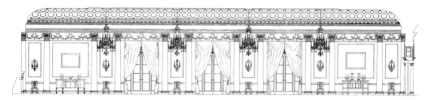

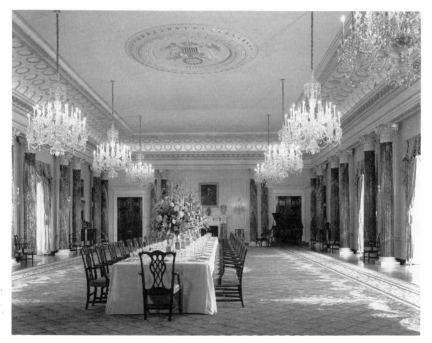

The wall as order: interior elevation and general view of the Benjamin Franklin State Dining Room at the Department of State, Washington, D.C., designed by John Blatteau Associates. Although this room has some remarkable features, including eight crystal chandeliers and a 92-foot-long Savonnerie style carpet, the architectural references of the surrounding columns are unconvincing because the spacing between them is disproportionately large for their size. *(Americana Project; Clement Conger, Curator; photograph: Matt Wargo, courtesy John Blatteau Associates)*

In special rooms of monumental character, however, the order can become explicit in the form of a parade of pilasters or even freestanding columns, and, in other cases, columns will have been replaced by paneling as the connection between base and cornice; in still others, those rooms with wainscoting or with chair rails, the implicit order is one of a column resting not directly on the floor but on a pedestal.

It is easy to overstate this wall/order analogy, and easy also to overembellish interior walls with elements intended for exterior surfaces. Adrian Stokes has noted the "rather self-conscious convention of providing inside doors with pediments, of decorating interiors with all the forms originating from protection against the weather."

But considering the wall as architectural order does emphasize the fact that, even when there is no obvious expression of such an order, the elements trimming a wall are necessarily related to each other and should be governed by a single character and a single family of proportions. The size and degree of complexity of a cornice molding should not be foreign to that of a base, the height of a dado should be in a pleasing ratio to the full height of the wall, and all should cooperate toward a single effect that the designer has predetermined.

The wall/order analogy can lend a sense of coherence and legitimacy to a wall surface by its reference to a structural system, even when the elements of that wall are performing no structural work. But this loan extracts a price: the result will not be persuasive unless the panels and pilasters of the wall *appear* to be spaced so that they *could* be functioning structurally. When this obligation is overlooked—when, for example, the spacing between vertical elements is so great that their relationship to the horizontal elements above them is hopelessly incapable of representing actual support—the integral tension that binds together a structural system is dissipated, and the disposition of parts is exposed as arbitrary.

Comparing walls to classical orders may also remind us that these orders can be read as metaphors for the human body, the stocky Doric order representing a masculine figure, the more slender Corinthian being feminine. "There is no doubt that the members of architecture depend on the members of man," Michelangelo thought. "You cannot understand architecture unless you have . . . a sound knowledge of anatomy."

Walls, as well as other architectural elements, can obviously be considered as metaphors for our bodies. They can also (as in Henry James's short story "The Jolly Corner") be used as metaphors for mental states. Walls also remind us of older walls and therefore of former

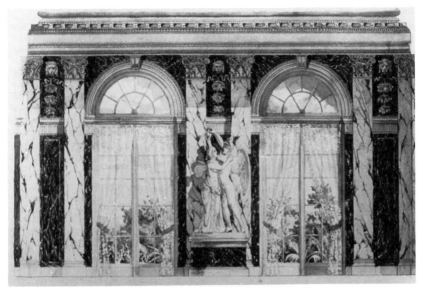

The wall as order: more correct and therefore more persuasive is this spacing of pilasters in an 1896 rendering by Ogden Codman, Jr., for the Nathaniel Thayer dining room. *(The Metropolitan Museum of Art)*

situations, of former homes, of childhood. They can be confining as well as sheltering, as in this blues lyric by Willard Robison:

> *I got the four walls and one dirty window blues.*
>   *I got the four walls and one dirty window blues.*
> *If I had saved my money*
>   *When I was young and well,*
> *I wouldn't be up here sweatin'*
>   *In this che-ee-eap hotel.*
> *I got the four walls and one dirty window blues.*

Martin Heidegger has considered walls philosophically, seeing them not just as limiting boundaries but also as prime sources of character for the spaces they help form: "A boundary is not that at which something stops, but as the Greeks recognized, the boundary is that from which something begins its presencing." This is obvious to us when we think of the nature of any of the important large interiors we know: cathedral, train shed, hotel lobby, or convention hall—their characters spring not from the area, however spacious, between their walls but from the walls themselves, however distant.

The manipulation of interior volume is the special province of architecture and interior design. (In Geoffrey Scott's words, architecture has "its peculiar province and a pleasure which is typically its own." Among all the arts, it has "a monopoly of space.") But the

nature of a volume derives from its boundaries, and designers must keep in mind the transparency, the neutrality of mere air. Heidegger again: ". . . spaces receive their being from locations and not from 'space.' "

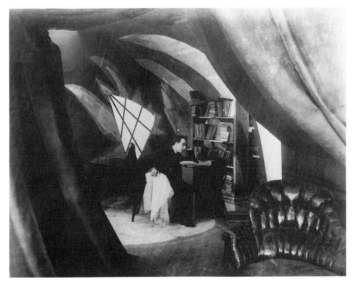

When the usually rectilinear enclosing surfaces assume unusual angles and the openings in them take uncustomary shapes, the results can be disorienting. This scene is from the 1919 German film *The Cabinet of Dr. Caligari*; set designers were Hermann Warm, Walter Rohrig and Walter Reimann. *(Courtesy The Museum of Modern Art Film Stills Archive)*

Although we look most directly at the walls of a room, its ceiling and floor play major roles as well. It is the ceiling, after all, that changes a space from exterior to interior. This covering of a space has obvious physical consequences of climatic protection and visual privacy. It has psychological consequences as well; our actions and thoughts within a room are given significance by the nature of that room and by the mere fact of being inside.

For all its significance, the ceiling is today the most neglected element in interior design. Too many of our designs stop at the cornice

In Kisho Kurokawa's Nagoya Museum of Modern Art, the coffee shop walls, floor and ceiling participate in an animated three-dimensional composition. *(Photograph: Tomio Ohashi, courtesy Kisho Kurokawa Architect & Associates)*

**A distorted perspective view emphasizes the ceiling and its services in a screening room for the Lowe/Marschalk advertising agency designed by New York Architects.** *(Courtesy New York Architects)*

line, as if the plane over our heads were beyond the designer's interest or control. It is not uncommon to see an executive office with paneled walls and fine antiques in a scrupulously detailed eighteenth-century style, but with a ceiling of two-by-four-foot lay-in acoustic tiles punctuated by fluorescent lighting fixtures; the result, of course, is ludicrous.

Not only does the ceiling deserve to partake of whatever design theme rules beneath it; it also has particular problems of its own that the designer must face. These result from the fact that the ceiling is the major source of our benefits from modern technology. Much of our lighting is in the ceiling; so generally are supply and return grilles for heating and air conditioning; so often are speakers for public address systems; so are numerous safety accessories, such as smoke detectors, sprinkler heads, and exit signs. If all these have not already been organized in some orderly pattern, it is the duty of the interior designer to attempt such an organization.

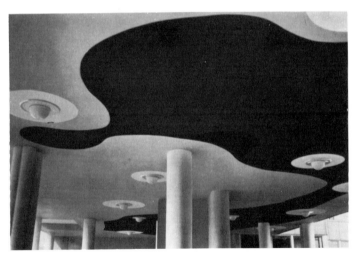

Free-form decorative liberties with the ceiling plane in a 1957 Berlin apartment block by Alvar Aalto.

At the bottom of every interior design is a floor. For children, it is often used for seating; for more decorous, less limber adults, contact with it is primarily with our feet and, of course, with our eyes. Because it is so apparent and so accessible, it seems to plead for decorative treatment, and, because carpets and rugs cushion our step and reduce sound reverberation, they are an obvious answer. Edgar Allan Poe, in an essay titled "The Philosophy of Furniture," pronounced that "The

Thomas Leeser's Gold Bar, "probably the most uncomfortable place in New York" because of its tilting surfaces and gaps in the floor. *(Photograph: Jeff Goldberg, courtesy ESTO)*

soul of the apartment is the carpet. From it are deduced not only the hues but the forms of all objects incumbent" and that "A judge at common law may be an ordinary man; a good judge of a carpet *must be* a genius." Clearly, however, there are schemes in which the obvious answer of carpeting is not the right answer and in which the floor's plea for decoration is best ignored.

The floor is also our primary source of a feeling of stability and security. We enjoy the knowledge that the structure beneath us is solid, firmly fixed and level. "The characteristic of a floor is its levelness," English architect and educator W. R. Lethaby has pointed out. But even this rule has its exceptions: in rare cases the designer may deliberately tamper with the solidity of the floor in order to create a sensation of danger or alienation. In the Gold Bar, on East Ninth Street in New York, the floor of steel plate is slightly tilted, cracks between the plates let light through from below, and at one point the floor opens in a fifteen-foot-long gap through which rises the bar itself, its top also slanted and its sides faced with gold leaf. The designer and co-owner of this unlikely establishment is the architect Thomas Leeser, quoted in *The New Yorker* with this description: "It's a weird place . . . probably the most uncomfortable place in New York. And the most scary place. And the most unsettling place. Once, somebody walked in and after a while he just got sick. Not from too much alcohol—I think he just got dizzy. He was sitting there, and the floor was tilted, and he just got this vertigo effect. . . . The work I'm doing always has to do with this aspect of being uncomfortable—with questioning people's expectations and behavior. . . . I like to disturb, to challenge."

A special case, obviously. But in more conventional interiors, changes of level in the floor plane can have a profound, often exhilarating, effect.

# CHANGING LEVELS

W E HAVE TALKED ALREADY of horizontal movement into and through interiors. Vertical movement, either real or imagined, is also important in interior design. Jung and Bachelard have both written of the attic and the cellar as images of psychological states, and Bachelard has written specifically of the "dual vertical polarity of a house" subject to the pulls of upper and lower regions beyond the usually inhabited spaces. It is these subsidiary regions, he says, that make the house such an effective shelter for our imaginations: "Of course, thanks to the house, a great many of our memories are housed, and if the house is a bit elaborate, if it has a cellar and a garret, nooks and corridors, our memories have refuges that are all the more clearly delineated."

When we think of these upper and lower regions, Bachelard points out in a way that effectively characterizes them, we always *go down* the stairs that lead to the cellar; it is the going down that we remember vividly, not the returning; and, similarly, "we always *go up* the attic stairs, which are steeper and more primitive. For they bear the mark of ascension to a more tranquil solitude. When I return to dream in the attics of yester-year, I never go down again."

These regions are indeed different from each other, and they fuel different memories. The attic's dry heat envelops us as we rise above the insulated part of the house; here, among the roof framing, are the family's stored treasures—scrapbooks of newspaper clippings, old phonograph records and curtain rods, outgrown toys, outmoded clothes.

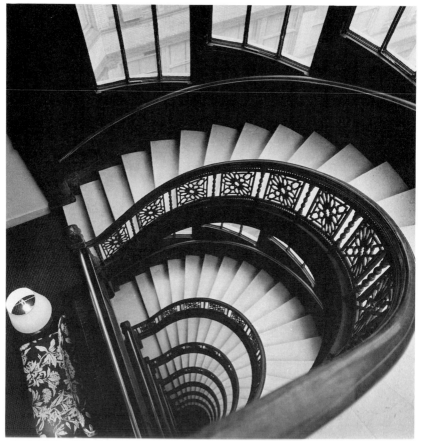

The great open stair of Burnham & Root's 1886 Rookery Building, Chicago. *(Photograph: Bill Engdahl, courtesy Hedrich-Blessing)*

In contrast, things are cooler and more damp as we descend to the cellar, the region of the base things that fund our upstairs comfort: the boiler, the coal bin, the damp, sweating pipes, the spidery corners harboring hoes and shovels.

The attic is dusty, but the cellar is dirty. The cellar, buried in the earth, is thought of as both more primitive and more structurally secure than the attic, surrounded by air. It is unimaginable that the Phantom of the Opera would have found his home in the attic; he could be sheltered only in the underworld. "When we dream there," Bachelard says, "we are in harmony with the irrationality of the depths."

The cellar, being more crude, may also offer the better escape from the refinements of the parlor floor. "When I consider how our houses are built," Thoreau speculated, "I wonder that the floor does not give

way under the visitor while he is admiring the gewgaws upon the mantelpiece, and let him fall through into the cellar to some solid and honest though earthy foundation." The cellar may also be thought of as being more permanent than the rest of the house. Thoreau again: "Under the most splendid house in the city is still to be found the cellar where they store their roots as of old, and long after the super-structure has disappeared posterity [will] remark its dent in the earth. The house is still but a sort of porch at the entrance of a burrow."

At Oakwell Hall in West Yorkshire, a stair to an upper level is made to seem unusually mysterious by the addition of gates. While these were meant only to deny access to the household dogs, they give people pause as well. *(Courtesy Kirklees Council, West Yorkshire)*

Thoreau knew the virtues of upper regions, too: "Should not every apartment in which man dwells be lofty enough to create some obscurity overhead, where flickering shadows may play at evening about the rafters? These forms are more agreeable to the fancy and imagination than fresco paintings or . . . the most expensive furniture."

This praise of attic and cellar should not be—in most cases, cannot be—taken literally. Few of the designer's assignments will allow the inclusion of such spaces. Even Bachelard himself seems to consider such appendages as relics. "A tower," he says, "is a creation of another century. . . . A new tower would be ridiculous." Still, the de-

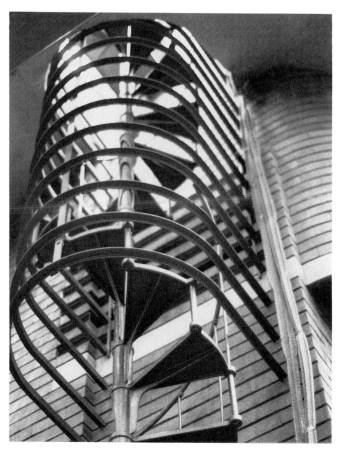

An alternative experience: At Wingspread, Frank Lloyd Wright's 1937 house for Herbert F. Johnson, near Racine, a stair climbs not to a dark attic but to the air and light of an observatory tower. *(Photograph: author)*

signer's clients may have some emotional need for subsidiary areas remote from the mainstream, places bypassed by traffic, unadorned by fine objects and high polish, quirky refuges from the general order. Such areas may be found more often than we would expect. Even Mies van der Rohe's Crown Hall, the paradigm of clarity, transparency, and exposure, has a basement in which there are rooms relatively dark and reached by relatively indirect paths. It is true that Wright considered basements "unwholesome" and banished them from his house designs, but at least we can say that he realized their psychological significance.

(In my own working environment, a magazine's editorial office, I find the equivalent of attic/cellar in an out-of-the-way storeroom for back issues and old bound volumes of the magazine. The only change of level is that of a quarter inch, from the carpet tiles that floor all the rest of the office down to the raw concrete slab; nevertheless, the character of this storeroom, its quiet, the smell of the old bindings, the change of attention from tomorrow's deadline to the record of sixty years past, makes this room for me—though I visit it only rarely, and then usually after other workers have left for the day—a place of refreshment.)

Not only do upper and lower regions have their peculiar characteristics, but it is also true that the means of reaching these regions are unlike anything else in interior design. For those using them, stairs, ramps and escalators (and even elevators if they are not entirely enclosed) provide a changing point of view freed from our usual earthbound station. As we climb, the interiors around us change, different features coming into focus while others recede. Our relationships to our fellow inhabitants also change, bringing into view such novelties as the hems of their skirts or the tops of their heads, and a similar spectacle is provided for those who remain on one level but observe the ones ascending or descending. Stairs are wonderful theater.

It is not always appropriate, of course, to take advantage of theatrical opportunities, and the designer may want to keep some stairways simple and out of sight. Such was the case with Thomas Jefferson in his design for Monticello, which, for all its grace and grandeur of effect, connects its four levels with a pair of small, steep stairs, inconspicuously located. Visitors are often surprised at how mean these seem, and a contemporary of Jefferson's described one as "a little ladder of a staircase." In part this was, for Jefferson, a matter of space-planning practicality; grand staircases, he thought, "are expensive, and occupy a space which would make a good room in every story." Jack

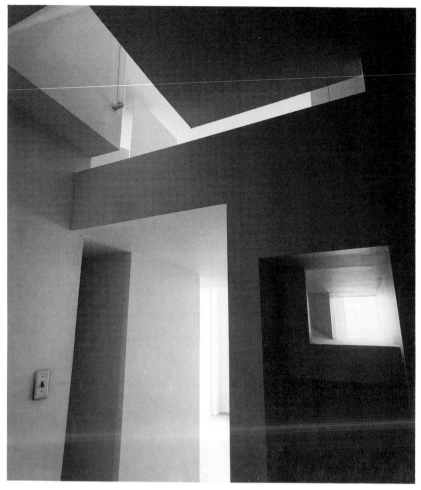

In George Ranalli's own New York studio, gaps between wall and ceiling planes allow unusual glimpses into other realms. *(Photograph: George Cserna)*

McLaughlin, in a recent book about the house, speculates that its stairs are minor because they were meant to be used very seldom by the master of the house, whose bedroom was on the ground floor, but only by children, slaves and temporary visitors. McLaughlin also imagines that Jefferson's democratic spirit ("All men are created equal") would have been offended by the grand stairway's accommodation of the ceremonies of rank and privilege. Another reason may be that more prominent stairs would have betrayed Jefferson's architectural subterfuge of disguising a multistory building to appear, from the outside, as if it were one story only.

In any case, such reticence is rare, and the interior designer will

more often relish the stair's propensity for drama. And some interiors, naturally, will need several stairs, each with its own character. Georges Teyssot has quoted Rainer Maria Rilke's childhood memories of "the stairways that descended with such ceremonious deliberation, and other narrow, spiral stairs in the obscurity of which one moved as blood does in the veins."

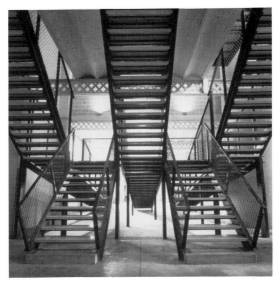

For La Lluana, their 1985 conversion of a Barcelona factory into a school, architects Enric Miralles and Carme Pinós devised a complex composition of stairs and ramps. *(Photograph: Ferran Freixa, courtesy Enric Miralles)*

One of Jefferson's steep, narrow stairs at Monticello: the result of economy, of aversion to pomp, or of subterfuge? *(Courtesy Monticello)*

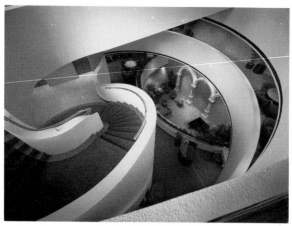

An interior invigorated by views from level to level: Harry Seidler's Hong Kong Club, Hong Kong, 1985. The stone arcade on the lowest level is a relic from a previous building on the site. *(Photograph: John Gollings, courtesy Harry Seidler & Associates)*

While other elements of our interiors may support either motion or repose, the stair seems devoted to motion, and its character decided by the type of motion it fosters. Steen Eiler Rasmussen in *Experiencing Architecture*, for example, notes that the Spanish Steps in Rome "were built in the seventeen-twenties when the farthingale was in fashion" and imagines the men and women of the time moving "gracefully on those steps which so closely resemble the figures of one of their dances—the men in high-heeled shoes with toes turned out as they had learned from their fencing masters, the women in tight-laced bodices above their dipping and swaying farthingales." Thus, he says, we see in the stair design "a petrification of the dancing rhythm of a period of gallantry." The Spanish Steps are outdoor, of course, but the same principle applies to the stairs of our interiors. Their consideration, in fact, leads Rasmussen to this observation in the next sentence: "If we believe that the object of architecture is to provide a framework for people's lives, then the rooms in our houses, and the relation between them, must be determined by the way we will live in them and move through them."

Different levels and the climbing devices that join them are more than opportunities for evoking psychological states and more than opportunities for unusual points of view; they are also exceptional opportunities for the interior designer to indulge in sculptural impulses. Stairs, ramps, and escalators are uncommon objects in interior design and are susceptible to a wide variety of physical forms, each expressive of a different attitude. The wise designer will manipulate

these forms to reinforce the basic concept of the spaces through which they pass.

Other physical exceptions to the singularity of a room, similarly subject to a multitude of expressive effects, are the openings that link the room to other rooms or to the outdoors, its doors and windows.

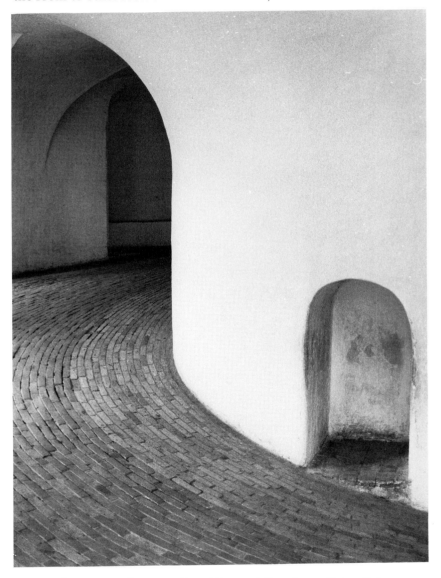

In the seventeenth-century Round Tower of Copenhagen University's Trinitatis Church, a spiral ramp invokes curiosity about what lies around the bend. *(Photograph: author)*

# DOORS AND WINDOWS

D OOR" IS A WORD WITH TWO MEANINGS: either an opening
that provides access or an object that closes such an opening.
The second kind of door negates the first, which, if we want to avoid
confusion, can be called a doorway. Both kinds of door have been
around a long time, since man first found shelter in a cave and then
rolled a stone across its mouth to keep the wolves out.

As man's needs have developed in complexity, his uses for doors
have multiplied. Doors in exterior walls can still protect us from
wolves and from weather, but they and the doors throughout our in-
teriors protect us from one another as well.

Phyllis McGinley calls the inventor of the door, with its gift of
privacy, "as much mankind's benefactor as he who discovered fire."
In her essay "A Lost Privilege," quoted in Robert Gutman's *People
and Buildings*, she writes, "The poor might have to huddle together
in cities for need's sake, and the frontiersman cling to his neighbor for
the sake of protection. But in each civilization, as it advanced, those
who could afford it chose the luxury of a withdrawing place. . . . Pri-
vacy was considered as worth striving for as hallmarked silver or linen
sheets for one's bed."

Because of their control over isolation and circulation, doors can
be likened to the valves between bodily organs, the synapses between
brain cells, the hinges between machine parts. "If one were to give an
account," Bachelard says, "of all the doors one has closed and opened,
of all the doors one would like to re-open, one would have to tell the

story of one's entire life." Doors are the essential links, the instruments that make connections between rooms and allow them to function together as the designer intends.

Frederick Kiesler's 1946 set for Sartre's *No Exit:* a sealed room as metaphor for hell. *(Photograph: Samuel H. Cottscho, courtesy Library of Congress)*

Doors, in determining connections, map our paths from room to room, paths that we experience mentally before we trace them physically. Even when we are stationary in a space, its doors suggest the possibility for exit, and a severe restriction of these possibilities can be disturbingly claustrophobic. (In Sartre's *No Exit*, a sealed room constitutes hell.) Heidegger, writing of the disjunction between imagined and actual movement, pointed out that "in going through spaces we do not give up our standing in them. Rather, we always go through spaces in such a way that we already experience them by staying constantly with near and remote locations and things. When I go toward the door of the lecture hall, I am already there. . . . I am never here only, as this encapsulated body; rather, . . . I already pervade the room, and only thus can I go through it."

French doors in Agrigento focus a hotel room's view on the so-called Temple of Concord across a valley. *(Photograph: author)*

Doors are more than linkages between spaces; at the same time, they are important physical events in those spaces. To place a door in the wall of a room is to change that wall and that room profoundly. On the most practical level, the designer should remember that doors consume both floor space and wall space. Emily Post warned that "many doors—especially double ones—make a small room smaller, because the floor space is turned into a cross-roads. Hence Rule One: The smaller the room, the fewer and smaller the doors." The designer will, obviously, find many exceptions to Rule One.

All doors are not equal, of course, and the designer must be sensitive to the societal rules that will determine how, and by whom, each door can be used. The chief executive officer of a company may enter a clerk's cubicle at any time, but not the clerk the CEO's office, and even for the CEO it would be unseemly to open the clerk's file drawers (horizontal doors) and go through the contents. Similar door-usage rules apply to parents and children, teachers and students, the chorus line and the Broadway star.

Further, doors that swing outward along our path have implications different from those that swing inward toward us. Double doors produce different psychological effects from single ones, wide doors different impressions from narrow ones. As a further complication, there are revolving doors, which art critic Brian O'Doherty, in describing a gallery installation by Marcel Duchamp, characterized as "doors that confuse inside and outside by spinning what they trap."

In *feng shui*, the three-thousand-year-old Chinese art of placement, the door is a pivotal element called *ch'i kou*, or the mouth of cosmic energy. Using Sarah Rossbach's *Interior Design with Feng Shui* as our introduction, we find many rules that seem, to nonparticipants, comic ("In offices, fish are used to absorb accidents. . . . Chalk under the bed to cure a backache. . . ."). Nevertheless, most of the dicta make perfect sense even to Westerners. On the important subject of doors, for example: "Door size is important. A door should be in proportion to house or room size. . . . The closer the bedroom is to the front door, the less peace residents will feel. . . . Beware of opposite doors that appear aligned but are actually askew. . . . Doorknobs that knock together like gnashing teeth can create family conficts. . . . Entrance doors should open to the widest area of the room or foyer. . . . If you work with your back to the door, you will partially expect someone to enter behind you and interrupt you. As a result, your effectiveness and productivity will decrease." A modern team of environmental scientists would have said it differently, and certainly at greater length, but

**Windows, such as this one in Kathmandu, can dramatize the people or objects they frame.** *(Photograph: author)*

hardly better. These affirmations of standard practice from an exotic source remind us how greatly interior design is based on common—universally common—sense.

There is a measure of overlap between doors and windows, an area of ambiguity in which either name would be permissible. Pairs of French doors opening to a garden have some of the characteristics of windows, certainly, and Jefferson's tall triple-hung windows on the garden side of Monticello and at Bremo, with the possibility of raising both the lower sashes to create a door-height opening, combine the qualities of both.

But these are unusual cases. Most of our windows are nothing like doors. Although we can, if we like, climb through windows, we generally move through doors but only look through windows. Henry James acknowledged the difference in his preface to *The Portrait of a Lady*: "The house of fiction has . . . not one window, but a million. . . . They are but windows at best, mere holes in a dead wall, disconnected, perched aloft; they are not hinged doors opening straight upon life."

Another difference is that doors function identically in both directions, for going out as well as for coming in, and windows do not. They are for looking out by those inside, not generally for looking in. To peer into the window of someone's house is an antisocial act. Even Thoreau, contrary to the norm in so many ways, recognized this custom. "It costs me nothing for curtains," he wrote, "for I have no gazers to shut out but the sun and moon, and I am willing that they should

look in." Obvious exceptions include the windows of shops and show-rooms, which are meant to catch the eyes of those outside and to provide enticing views of merchandise.

Other exceptions, however little we may like to admit it, are some residential windows that are used to signal the taste and affluence of the inhabitants, the "picture window" of the typical tract house of a generation ago, for example, being designed less to give those inside a view of the lawn and the tract house next door than to give the neighbors a view of elaborately draped curtains and, centered in the plate glass, a would-be beauty of a lamp, thereby establishing the owner's respectability or even—if the lamp is *truly* extraordinary and has a tasseled shade—superiority. Thorstein Veblen's 1899 classic *The Theory of the Leisure Class* rather uncharitably saw such window displays as intending merely to "impress their pecuniary excellence upon the chance beholder from the outside" and as being disruptive of the design of the room beyond, as "the detail of interior arrangement is required to conform itself as best it may to this alien but imperious requirement."

But because windows are generally for looking out rather than in, they seem to belong particularly to the rooms inside. Indeed, its windows and the views beyond them are major determinants of a room's character, serving a purpose not entirely dissimilar to one role of furniture: to relieve, intrigue, and delight our eye. As is the case with doors, the interior designer will only rarely have control of the placement of windows and even more rarely of their views, yet their nature must always be considered in designing the rooms to which they open.

When a designer is allowed to determine window placement, the number of choices may seem overwhelming. Whereas such placement was once strictly circumscribed by formal considerations of building exteriors, by structural limits and by climatic needs, the window is now often liberated from all these constraints. Freed from structural limitations as the bearing wall has been replaced by a series of point supports, the unrestricted window is a key element in Le Corbusier's "free facade." It is not necessary, however, to take advantage of every available freedom, and the designer will still want to control inside/outside relationships, to select window sizes and positions, and to restrict views. A wide view is not the ideal in every room; something less dramatic is sometimes preferred. (Although the philosopher Benedetto Croce is said to have written by a window with a splendid view in Sorrento and, when asked how he could manage to do so, said simply that "one gets used to it.")

Traditionally, the window has provided more than just views, in whatever direction. The window is a source of natural light in daylight hours, of course, and in many of our buildings it is still the major source of ventilation, although technology has long ago provided us with other means for this last function; as architect Rudolph Schindler predicted back in 1926, "The house of the future will abandon the present window and provide separate systems of openings for air and light."

The amenities a window offers us are desirable only in carefully controlled quantities, our appetites for them varying with time, weather and mood, so that the actual performance demanded of a window becomes quite complex: at varying times, to let in air but keep out rain, to allow view but maintain privacy, to let in light without cold (or excessively hot) air, dust, or noise, to let in air without light, and to vary at will the amounts of all these substances.

**In the Amber Fort near Jaipur, a pierced marble screen modulates the strong sunlight.** *(Photograph: author)*

 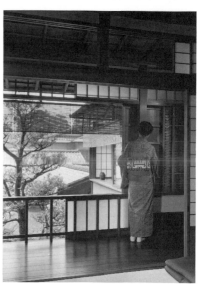

The traditional Japanese house offers many ingenious devices for adjusting the permeability of the exterior wall. Four successive views show the same wall in various stages of openness. At upper left, the innermost layer of paper *shoji* is closed. At upper right, lower half of *shoji* is raised, but glazed panel keeps out outside air. At lower left, inner panels are open, but outer wood shutters, across a narrow passage, are closed; *shoji* panels in transom slide independently of those below. At lower right, outer wood shutters slide into storage pocket at right; bamboo blind rolls down for further control of light. *(Photographs: Ezra Stoller, courtesy ESTO)*

It is for the purpose of such control that we have supplemented our windows with an abundance—we might say a plethora—of window coverings: shades, shutters, blinds, curtains, pelmets, festoons, swags, lambrequins, valances, portieres, drapes and overdrapes. Just as doors and windows are modifications to a wall that make it more permeable, these window coverings are modifications that give a room's occupants more control over that permeability. In addition to filtering physical factors, they frequently are also major determinants of a room's character. In the first languorous sentence of *Absalom, Absalom!*, Faulkner establishes an atmosphere for the whole novel with this description: "... a dim hot airless room with the blinds all closed and fastened for forty-three summers because when she was a girl someone had believed that light and moving air carried heat and that dark was always cooler, and which (as the sun shone fuller and fuller on that side of the house) became latticed with yellow slashes full of dust motes which Quentin thought of as being flecks of the dead old dried paint itself blown inward from the scaling blinds as wind might have blown them."

In many periods design attention has been drawn, as by a magnet, to the window, sometimes with the result of completely overwhelming it, leaving us a potential amenity rendered useless. Fabric and fringes have their proper place, of course, but it should not be forgotten

**Window shape alluding to history: In the 1988 Municipal Museum of Contemporary Art, Kyoto, by Fumihiko Maki, the profile of a wall opening recalls the window in the nearby fifteenth-century Ginkaku-ji garden.** *(Photographs: author)*

that the origin of window coverings is in the need to give the user increased control over light, air, and view. If a window treatment becomes so elaborate, heavy, opaque or inflexible that this control is diminished, it will have defeated the window's very purpose. When this happens, it is often a case of reason sidetracked by custom. "Like the lapels on our coats," the eminently perceptive architect and critic Bernard Rudofsky wrote, "window curtains are vestigial features; their original purpose has slipped our memory."

The elaborately draped door to the dining room in a fashionable Liverpool House c. 1890. Going in to dinner was not a simple matter.

With the consideration of window treatment (and occasional overtreatment), we have gone beyond the elements over which the interior designer has control only at times—plans, rooms, changes of level, walls and openings in them—to those elements over which the interior designer always has control. Of these, the most important is furniture.

# FURNITURE

OUR FRIEND THOREAU, in his spartan cabin, took an extreme view: "I had three pieces of limestone on my desk, but I was terrified to find that they required to be dusted daily, when the furniture of my mind was all undusted still, and I threw them out the window in disgust. How, then, could I have a furnished house?" But even Thoreau, in another passage, conceded, "None is so poor that he need sit on a pumpkin."

Assuming we choose to have furniture in our designs rather than pumpkins, we will find it to be very prominent. Although it is only one element in interior design, it is often such a conspicuous one that we can be forgiven for sometimes considering "furnishing" a house or office a synonym for designing it. Indeed, furniture is often so visibly in the foreground of our interiors that its design must be considered not only as an ingredient in the designer's total scheme but also on its own artistic merits; it is seldom the case, even when it is "built in," that furniture plays a quiet role in the background of a design.

Like architecture and interior design themselves, furniture serves a practical function as well as an aesthetic one, so that furniture design is a complex art of compromise between use and beauty and of searching for solutions that satisfy both demands at once. Even so, furniture design customarily departs far more widely from the mere accommodation of function than does building design. At many stages of history, including our own, architects have occasionally imagined their design process as being guided purely by their efficient responses to

71

utilitarian demands; it is hardly possible to imagine the designer of a chair having such a simplistic notion of his work. There are, after all, not so many different ways of sitting in a chair, but the variety of appearances of chairs is endless.

**A built-in tile chaise in Le Corbusier's 1929 Villa Savoye, Poissy.** *(Photograph: Dorothy Alexander)*

All these departures from the mere accommodation of function are laden with messages, often very eloquent ones, and it is a critical part of the interior designer's education to become adept at reading these messages and then choosing which messages to send. Without such literacy, our finest rooms may be our most unpleasant ones, such as the front parlors of our grandparents' houses. "A parlor is a place," Gertrude Stein observed. "Who knows why they feel that they had rather not gather there." In his book *The House and the Art of Its Design*, Robert Woods Kennedy tells us why: because the parlor suggested "restraint, punishments, Bible reading, and unbearable boredom. Its furniture was stiff, uncomfortable, too delicate, and too neat."

Looking from a former fifteenth-century chapter house through a Moorish doorway into a former monastery cloister, now used as the dining room of a *pousada* in Évora, Portugal. Appropriate to their context, the chairs are simple but characterful. *(Photograph: author)*

**Furniture, for better or worse, can alter the character of a room, as in these drawings by Der Scutt.** *(From Tod Williams and Ricardo Scofidio,* Window, Room, Furniture, *courtesy Der Scutt)*

A useful exercise in reading the messages sent by furniture is the application of John Ruskin's "pathetic fallacy"—that is, the ascription to inanimate objects of human traits. While Ruskin meant his term to be pejorative, applying to the presence of "false appearances, when we are under the influence of emotion or contemplative fancy," it will do us no great harm to be temporarily under such influence.

I am grateful to an essay by Georges Teyssot for examples of writers' attributing to furniture sexual characteristics as well as animal and vegetable ones: Huysmans, for example, in *À rebours:* "The eighteenth century is, in fact, the only age which has known how to envelop a woman in a wholly depraved atmosphere, shaping its furniture on the model of her charms, imitating her passionate contortions and spasmodic convulsions in the curves and convolutions of wood." And Baudelaire in "The Double Room": "Each piece of furniture is of an elongated form, languid and prostrate, and seems to be dreaming; endowed, one would say, with a somnambular existence like minerals and vegetables." Then de Maupassant in "Qui sait?": "And then, all of a sudden, I saw, in the doorway, an armchair, my large reading chair, which went waddling out. It went off through the garden. Others followed it, those from my salon, then the low sofas dragging themselves like crocodiles on their short legs, then all my chairs with goatlike leaps, and the little footstools trotting out like rabbits."

This last, you may say, is a bit extreme. But this sort of vision—of furniture as bodily analogy as well as bodily support—is at the heart of historian Vincent Scully's deservedly celebrated flair for expressing the character of architecture and artifacts. Here he is (in *New World Visions of Household Gods and Sacred Places*) on the evolution of

eighteenth-century chair design: "Then, with Queen Anne furniture, around 1725, the whole chair becomes an active creature, an organic body. The arms curve; the splat lifts and gestures behind them. The back, with a wonderfully controlled curve, comes down and, often with a profoundly articulated hip joint, transmits its energies into the seat, which in turn transmits them to the legs. They are cabriole legs, and therefore they bend, almost crouch, and they terminate in feet of one kind or another. Eventually many of them become ball-and-claw feet, clutching and full of power. The whole chair becomes a kind of animal."

Not all chairs are so animated as this one, of course, which was exactly Scully's point in contrasting it with the more rigid turned wood "great chairs" of the Brewster type that preceded it. But if these were less anthropomorphic than Queen Anne furniture, they were equally communicative in their own stiff manner.

With Queen Anne furniture, according to Vincent Scully, the chair "becomes an active creature, an organic body." This walnut armchair, left, was made in Philadelphia 1725–50. Of a much sterner, less anthropomorphic character is the hickory and ash Brewster chair, right, from the middle of the previous century. *(The Metropolitan Museum of Art, Rogers Fund, 1925; The Metropolitan Museum of Art, gift of Mrs. J. Insley Blair, 1951)*

In an interesting essay, "The Seat of the Soul," philosopher/art critic Arthur C. Danto characterizes furniture in a slightly different way, according to the social activity it fosters. "The English wing chair," he writes, "in which we sit protected, and alone, and enclosed, facing the warmth of the fire, embraced by wings as if those of a soft sheltering angel, implies a different form of life and a different set of

Another difference of expression is seen in these two Italian musical instruments: above, a seventeenth-century Roman harpsichord supported by Tritons; the gilded gesso relief on the case shows the procession of Galatea; below, a Florentine pianoforte c. 1720. (So much for the dictates of function!) *(Both from The Metropolitan Museum of Art, The Crosby Brown Collection of Musical Instruments, 1889)*

values altogether from the precarious and portable salon chair of France, meant to be carried from place to place, from conversing group to conversing group, or to be arranged for a party of whist, or in a circle surrounding a string trio, and implying an essential sociability. . . . The salon chair's lightness and elegance stipulate the form of life to which it is organically connected; the wing chair's heaviness and solidity stipulate a different form of life—one of security, of solidity, of immobility, of peace. . . . One's chair is one's signature."

More briefly, Bernard Rudofsky noted that the chair "is more than a prosthesis, an extension of the human body; it provides a bolster for the mind. Among furniture, chairs are a race apart. They come . . . in both sexes, drab and gay, tweedy and frilly."

The language of furniture is not entirely obvious, of course. It is a language of connotation as well as denotation, of suggestion as well as statement, of symbol as well as sign. It is no easier to speak than to decipher. James Wines has pointed out that the essence of the "cue" or "trigger" effect identified by Jung as the element in any work of art evoking subliminal responses in its audience is "beyond the scope of normal design intentions. It is a distillation that must be grasped . . . on the most difficult level of conception in art—the ability to bridge the conscious and unconscious . . . —and then be translated into readable terms."

Jung is careful, Wines notes, to distinguish between signs and symbols. "The sign," Jung wrote, "is always less than the concept it represents, while a symbol always stands for something more than its obvious and immediate meaning. Symbols, moreover, are natural and spontaneous products. No genius has ever sat down with a pen or brush in his hand and said: 'Now I am going to invent a symbol.' No one can take a more or less rational thought, reached as a logical conclusion or by deliberate intent, and then give it 'symbolic' form. No matter what fantastic trappings one may put upon an idea of this kind, it will still remain a sign, linked to the conscious thought behind it, not a symbol that hints at something not yet known." Yet these things not yet known by our conscious minds are intuited subconsciously (for Jung, the source of our intuitions being our dreams), and the designer truly fluent in the language of furniture will be openminded to its symbols as well as to its more obvious declarations.

Thus conscious of the characters of the furniture pieces available, the designer must choose those appropriate to the interior's overall concept and those that will be compatible with each other. Emily Post's advice in 1930 was that "with chairs of the type of Chippendale,

you will perhaps choose a Sheraton sideboard, or a pair of Adam consoles, and quite possibly a dining-table in the style of Phyfe. If you choose Stuart or Elizabethan chairs, you will probably choose a bread-and-butter cupboard. Or if you choose old Colonial, you may choose a plate-cupboard or perhaps a milk-bench."

While some of her terms may now seem quaint, it is obvious that the principle is still sound that furniture need not precisely match in style to be compatible—a room with Chippendale chairs need not be furnished *all* in Chippendale—but that it does need to match in general feeling. The relatively restrained character of Louis XVI may be quite agreeable in the same room with fine Hepplewhite pieces, but the more baroque character of Louis XIV or the decorative exuberance of Louis XV may not, except as intentional contrast. Nor do stylistic changes occur only when reigns change; most Louis XV furniture is elaborately curvaceous; but before the accession of Louis XVI, it had become considerably more serious, more linear and flatter. It is the look, not the date nor the ruler, that determines compatibility, and it is commonly acknowledged today, for example, that modern pieces mix easily with traditional ones, as long as their personalities are compatible.

Pieces of furniture relate not only to one another and to general design concept, they relate very intimately to those who live with them. In Thomas Mann's short story "Tristan," a character frequently "carried away by an aesthetic fit at the sight of beauty" confides that there are times when he "simply must have" the static control of Empire furniture around him "in order to attain any sense of well-being. Obviously," he observes, "people feel one way among furniture that is soft and comfortable and voluptuous, and quite another among the straight lines of these tables, chairs and draperies. This brightness and hardness, this cold, austere simplicity and reserved strength . . . it has upon me the ultimate effect of an inward purification and rebirth. Beyond a doubt, it is morally elevating."

Mario Praz, author of the eloquent *House of Life*, spoke of this relationship in a 1981 interview in *Abitare* magazine: "The play of memory goes out to objects, relieving them of their utility or market value. They are then free to speak to us. . . . I believe the house to be a projection of the Ego, and furniture an indirect form of the cult of self. . . . The living space becomes a kind of museum of the soul where the occupant sees himself reflected and ever re-reads what he has been. And a good deal of furniture is a plaster-cast of the body, the body's receptacle, so the entire surrounding sets into a cast without which

A detail of Mario Praz's own quarters. "The living space becomes a kind of museum of the soul where the occupant sees himself reflected and ever re-reads what he has been." *(Photograph: Antonia Mulas, courtesy Abitare)*

The "brightness and hardness" of the Empire style. This painted and gilded cherry sofa, c. 1815, is probably from the workshop of Duncan Phyfe; it is upholstered in black haircloth. *(The Metropolitan Museum of Art, gift of Mrs. Bayard Verplanck, 1940)*

the soul would feel lost and in distress. Perhaps this is why—more even than painting, sculpture and architecture itself—it is furniture that reveals the spirit of an age and an ambience the character of its occupants. . . . Although the home as a mirror to the soul, place elect for our sense of intimacy, is a modern discovery close to us in time, by now it is part of our sensibility. The pull, the fascination places and things have for us lies in this flood of memories they summon up."

We choose furniture on the basis of function as well as on the basis of character, obviously. Divisions into categories of residential and commercial (or "contract") furniture are not always useful or even clear, there being many pieces useful for either type of installation. Underlying all the more specific categories—casegoods, executive seating, lounge seating, task lighting and on and on endlessly—we may say that there are three basic types of furnishings: those that serve our bodies, those that serve our possessions and those that serve only our senses.

The first of these types is the most necessary: our beds, sofas, and chairs. It may not be easy to think of these pieces—made to be sat on, reclined on or slept in—as anything but utilitarian, but it is not a trivialization of serious human needs to think of them also as art. Our choice of furniture, even of this most functional sort, is always influenced by its appearance.

The history of the chair is a long one, extending at least as far back as ancient Egypt (or, at least, to the ancient Egypt of the ruling class; it is doubtful that the Egyptian peasant ever sat on such an object). It probably first appeared in China, according to Fernand Braudel, in the second or third century A.D. In those early days, particularly, chairs were, as Rudofsky has said, "ceremonial objects, such as top hats are with us." Vestiges of this ceremonial quality, quite apart from considerations of mere function, cling to the chair even today; to speak with high authority is to speak "ex cathedra"—literally, from the chair.

Braudel tells us that "there must have taken place in China (some time before the thirteenth century) a major expansion of life-styles, accompanied by a separation between seated life and squatting life at ground level, the latter domestic, the former official: the sovereign's

**In the church of Sainte-Madeleine, Vézelay, as currently used, the carved wood pulpit for the priest is appropriately elaborate, contrasting with the plain chairs provided for the congregation.** *(Photograph: author)*

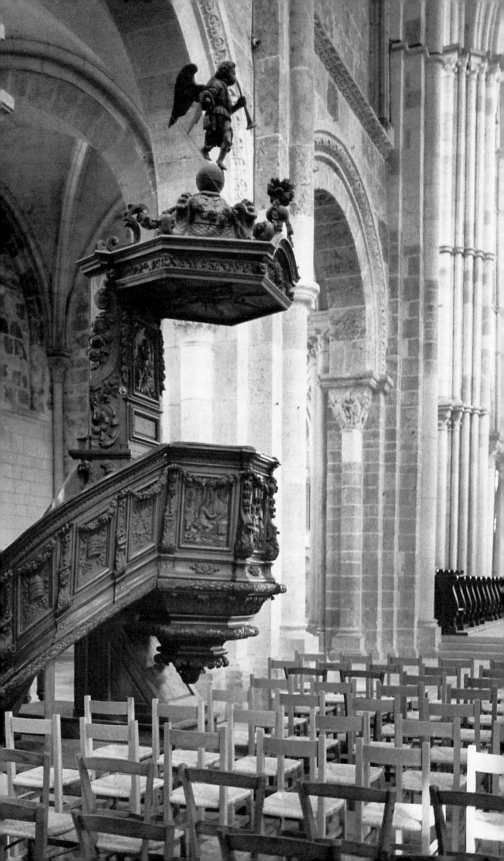

throne, the mandarin's seat, benches and chairs in schools. . . . [It] is worth while noting these two types of behaviour in the everyday life of the world: the seated position and the squatting position. The latter is omnipresent except in the West, and the two only came together in China. To find the origins of this behaviour in Europe would take us back to antiquity and the very roots of Western civilization."

Nonfunctional considerations are not limited to bishops and kings of past eras; they affect our own choices today. A chair's provision of proper support, even of comfort, is seldom directly related to its popularity. The so-called Hardoy (or butterfly or sling) chair, which was one of the most popular furniture designs of recent history, with— according to one estimate—more than five million of them being produced in the United States in the decades following World War II, and which, as this is written, seems to be enjoying a modest revival, is one example. Peter Blake and Jane Thompson, in an essay titled "A Very Significant Chair," have traced its lineage to folding camp chairs of the nineteenth century and to a patent granted in England in 1877. For all its century and more of favor, however, it can present problems for its users. Joseph Rykwert has outlined some of these in "The Sitting Position—a Question of Method": " . . . the seat, which is loosely suspended, will mould itself to the thighs and buttocks, and that support will not be concentrated, as is thought desirable, on the ischial tuberosities; also . . . there will be no lumbar support so that the spinal erectors will never be completely relaxed. The hard edge of the canvas must always press on the under side of the thighs and cause consider-

Window          room          Furniture

**Furniture, like a window, can bring visual interest to an otherwise routine room.** *(Drawings by the author for Tod Williams and Ricardo Scofidio,* Window, Room, Furniture)

The design of the Hardoy chair, popular in the 1950s and 1960s, has been traced by Jane Thompson and Peter Blake to nineteenth-century folding camp chairs. *(Courtesy Knoll International)*

able discomfort. What is worse, the fixed form framework and its high protuberances make any changes of position very cumbersome."

But in choosing a chair we follow the dictates of our eyes, for better or worse, more often than those of our "ischial tuberosities," and the hammocklike Hardoy *looks* comfortable. Rykwert correctly assumes that "the buyers of Hardoy chairs, like many other customers for design goods, are guided in their choice by promptings quite different from the dictates of reason." And he adds a conclusion worth remembering: "The very fact that they do so should be a matter of interest to the designer: nothing human should be alien to him."

If we consider seating stretched from the chair into the sofa, we will have further evidence against the strict supremacy of function, for the sofa is seldom used efficiently. If users are given a choice, a sofa long enough to seat three or four will seldom be sat on by more than two, one perched at each end. In the rare cases when it is fully utilized, the sofa still has its problems; the environmental psychologist Albert Mehrabian, in *Public Places and Private Spaces*, remarks that "if, in a crowded situation, four people are forced to sit together on a couch, the quality and quantity of conversation among these four will be nothing to write home about." He has even diagramed the likely conversations among eight people seated on and about a four-seat sofa and has concluded that "it is difficult to understand how couches have become such a standard item of living room furniture."

This scientific snobbery fails to take into account the sofa's real

In Richard Meier's 1973 Douglas House, Harbor Springs, Michigan, a view from above of a furniture grouping. Some of the pieces are built in, some are not; all are part of a carefully planned ensemble. *(Photograph: Ezra Stoller, courtesy ESTO)*

significance. It is second only to the fireplace (which long ago became superfluous as a source of heat) as a visible sign of graciousness and comfort. It gives a room a sense of importance that few other pieces of furniture can offer. Further, its size and appealingly long line are very useful parts of the designer's vocabulary, able to give identification and consolidation to a whole seating group, much as, in writing, a bracket can tie together the words it encloses.

How simple, how straightforward the meanings and connotations of chairs and sofas, however, compared to those of beds! These are the scenes of births and deaths, of sex and sickness, of many of our most private moments. "Few things," Anthony Burgess has noted, "give a better idea of a person than his bed. Not, of course, the bed in which he slept for one night in transit, but that of his habitual residence, chosen by him and surrounded by the distinctive atmosphere of his own taste." Burgess traces the bed, as others have the chair, back to Egypt and finds its use there equally ceremonial: "We may divine that kings and queens did not sleep any better on their ornate machines than peasants on their mud floors (Shakespeare is always going on about this), but the elaboration of a bed had nothing to do with somniference. It was all a matter of symbolism—weight, dignity, immovability. In other words, the kingly bed anticipated the kingly tomb, and even hinted at the possibility of resurrection. The solemnity of a monarch's going to bed foretold the glory of his obsequies."

In more humble situations where humans are to be accommo-
dated overnight—hotels, camps, prisons, hospitals—the bed becomes
the basic unit of interior design, not just as a synecdoche (the number
of "beds" representing a whole range of facilities for that number of
people), but also as the basic item of furniture in the facility. It is then,
perhaps, seeing clearly the ratio of one bed to one person, that we are
most aware of the bed's intimate nature. It is the piece of furniture
that most demands a private treatment; in some periods, in fact, it
came equipped with draperies that provided its own built-in privacy,
creating a miniature room within the room, not an unreasonable so-
lution to consider even now, although the modern taste for ventilation
finds bed curtains too confining.

**A canopied Elizabethan bed from Cumnor Place, Berkshire, late six-
teenth century.** *(The Metropolitan Museum of Art, gift of Irwin Unter-
myer, 1953)*

The bed, being so private, has been the victim of many private
whims, an extreme among these being the bed of a maharajah, a draw-
ing of which exists in the Musée Builhet-Christofle at Saint-Denis. Its
solid silver frame was presided over by four bedposts in the form of
realistically sculptured female figures with wigs of real hair. When the
maharajah lay down, mechanisms that detected his weight put into
gentle motion the feathered fans in the figures' hands, music automat-

A piece of furniture serving as both seating and storage is the Italian *cassapanca*. This example, of carved walnut, is from Florence, mid-sixteenth century. *(The Metropolitan Museum of Art, Rogers Fund, 1912)*

ically began to play, and buttons by the pillow caused various liquid refreshments to flow from the figures' nipples. Burgess, in addition to this description, has also written of "the Malay sultan" he visited "whose canopied bed is also a pornographic cinema."

But these inventive vulgarities are rare. Without looking at beds in detail, which is beyond the intended scope of this book, let us simply note that the bed, no less than the sofa and chair, the stool and the chaise, carries with it always a special significance because of its close contact with our bodies and their secrets.

The second basic type of furniture, serving not our bodies but our possessions, has its own mysteries. A temporary service of this kind is provided by desks, shelves, and tables. There are innumerable tables —dining-, coffee-, dressing-, conference-, operating-, bridge-, sewing-, kitchen-, end-, side-, bedside-, and on and on—all providing a resting place for objects. As with so many aspects of the interior, placing objects on tables is more than a simple functional matter, for, human nature being complex and devious, the things we place about us are

A library table with inlaid walnut top designed by A. W. N. Pugin for Abney Hall, Cheshire. *(Victoria and Albert Museum)*

not necessarily those that we are about to use or even necessarily those that we enjoy seeing but often those that we like others to see. Another kind of table is sometimes called a vanity, but, to some degree, every table deserves the name.

Possessions can also be exhibited above table height on arrangements of open shelving. The étagère, newly popular at the time, was described in an 1850 magazine as a resting place for "elegantly bound books and *bijouterie* of all descriptions." Braudel records similar uses of display furniture about the sixteenth century: "For example, the dresser started life in the kitchen as an ordinary table on which were placed the dishes and loads of crockery required to serve a meal. In seigneurial houses a second dresser made its way into the drawing-room: on it were displayed the gold, silver and vermeil services, the bowls, *aiguières* and goblets. Etiquette prescribed the number of shelves it should have according to the status of the master of the house—two for a baron, the number increasing with rank." The king, in top rank, was allowed eight shelves.

But the deeper mysteries belong to those pieces of furniture designed to enclose and store things for longer periods of time. The function of such furniture was described by Le Corbusier as being supplementary to our own minds and bodies. "Filing cabinets," he said, ". . . make good the inadequacies of our memory; wardrobes and sideboards are the containers in which we put away the auxiliary limbs that guarantee us against cold or heat, hunger or thirst."

Casegoods is a current name for these pieces of furniture, but their

**Thirteenth-century armoire, Bayeux Cathedral.**

history, as someone has said, is as old and as odd as the history of human possessions. Putting objects out of sight is not putting them out of mind, and these pieces of furniture can be more evocative than tables, which hold objects in plain view. "With the theme of drawers, chests . . . and wardrobes," in Bachelard's words, "we shall resume contact with the unfathomable daydreams of intimacy. Wardrobes with their shelves, desks with their drawers, and chests with their false bottoms are veritable organs of the secret psychological life. . . . Every poet of furniture—even if he be a poet in a garret, and therefore has no furniture—knows that the inner space of an old wardrobe is deep. A wardrobe's inner space is also *intimate space*, space that is not open to just anybody." And, perhaps most tellingly, "There will always be more things in a closed, than in an open, box."

Putting possessions away does not diminish our pride in them, so that by no means all our containers are unobtrusive; many are quite prominent. We may want to store out of sight our clean towels and

Left: an early-eighteenth-century walnut veneer writing cabinet said to have belonged to Jonathan Swift. *(Victoria and Albert Museum)* Right, with similar function but quite different appearance is an escritoire, c. 1868, painted by Charles Rossiter.

Four pieces of furniture with similar storage functions. Upper left, Bruce Talbert's Juno cabinet, made of ebony inlaid with ivory, winner of the Grand Prix at the Paris Exposition Universelle in 1878; upper right, the Carlton cabinet designed by Ettore Sottsass for Memphis; lower left, an ebonized sideboard in the Japanese manner, 1867, designed by E. W. Godwin for his own use and made by William Watt; lower right, an oak writing desk by C. F. A. Voysey. *(Photograph of Sottsass cabinet courtesy Furniture of the Twentieth Century; all others Victoria and Albert Museum)*

certainly our dirty ones, our insurance policies, our computer disks, our shirts and bracelets and groceries; we may seldom want such things cluttering the visible parts of our interiors, but we may also want to make sure that our neighbors and colleagues do not imagine us lacking in all these things. And so we devise storage walls, files, armoires, wardrobes, chests, secretaries, highboys, lowboys and jewelry caskets that do not reveal their contents but that clearly advertise that there *are* contents. This is furniture not of action but of implication.

Such secretive yet communicative pieces are often given added eloquence by hardware that is expressive of the acts of closing and fastening: hinges, handles, knobs, pulls, locks and lock escutcheons. And, of course, presenting as they do closed and opaque surfaces to the world, these pieces frequently have those surfaces elaborated by decorative treatments. But here we approach the third category of furniture, that which caters to our senses.

Some of these last may be said to be quite utilitarian, providing or tempering qualities of light, sound or heat in our interiors or offering various kinds of entertainment. But many others serve only our visual pleasure; the function of a room would be just as efficient and the comfort level just as high without them. They deserve a chapter of their own.

# ORNAMENT

SURFACES OF MOTHER-OF-PEARL, of sisal, of shagreen, of pol-
ished oak burl, of fragrant cedar, of marble or malachite, hangings
of sheer voile or dense velvet, trim of polished chrome or woolen fringe
—so many materials for the designer, and almost all of them available
in bewildering varieties of finish and color. And these are merely the
"plain" decorative materials, not the figured and patterned ones that
add another million possibilities. With such a vast buffet to choose
from, it is little wonder that, according to present taste, some of our
predecessors chose too much.

It is a tricky thing to get a balanced opinion of ornament. Neither
the most consequential part of an interior nor yet inconsequential, it
has at times been overrated, at other times unfairly disparaged. Ac-
cording to Joan Evans, who wrote several graceful books on the sub-
ject, "Pattern is not an essential thing. It is an ornamentation of
surface which affects neither shape nor function. . . . Beautiful, pat-
tern may be and often is: but beauty can and does exist without it."

It was in reaction to what they saw as the decorative excesses of
the Victorians that the pioneers of modernism decided that there must
be something fundamentally wrong with *all* decoration. The Viennese
architect Adolf Loos, who paired "Ornament and Crime," maintained
that the more cultivated a civilization becomes, the more its decora-
tion disappears. Loos associated ornament directly with the criminal
character, warning that there were "prisons in which eighty per cent
of the prisoners are tattooed," and, somewhat less unreasonably,

One of a pair of French ormolu firedogs, c. 1790, presents an extravagant display of ornament not at all needed for supporting logs. The originals are in the Cleveland Museum of Art.

thought that, by 1908 in Vienna, educated society had arrived at something better. "We have art," he said, "which has replaced ornament. We go to Beethoven or *Tristan* after the cares of the day.... But whoever goes to the Ninth Symphony and then sits down to design [a] wallpaper pattern is either a rogue or a degenerate."

What, specifically, was ornament's crime thought to have been? One accusation by its detractors was that it was highly eclectic and therefore not representative of sincere conviction or secure taste. Le Corbusier in *The Decorative Art of Today* (the day was 1925) deplored interiors that mingled "Argentine tangos, Louisiana Jazz, Russian embroidery, Breton wardrobes, faience from almost everywhere, *Japonaiserie* of all kinds—a sentimental and decorative hubbub, quite *ersatz* ... invented by others and filling whatever empty holes may be left in our crowded days."

More basically, the modernists resented ornament because it got in the way; it obscured something that they had come to see as important: the structure of building and its expression in good materials and fine craftsmanship. Le Corbusier quoted the great French architect Auguste Perret—"One must build with perfection: decoration generally hides a want of perfection"—and went on to point out that "a cast-iron stove overflowing with decoration costs less than a plain one; amidst the surging leaf patterns flaws in the casting cannot be seen."

Louis Sullivan, one of the modern age's great ornamentalists, said of his 1889 Auditorium Building in Chicago that its "plastic and color decorations are distinctly architectural in conception." By this, did he mean that they were meant to be as bold and prominent as the architecture itself? No, apparently he meant just the opposite: "They are everywhere kept subordinate to the general effect of the larger structural masses and subdivisions, while lending to them the enchantment of soft tones and of varied light and shade."

The year the Auditorium Building was built, Veblen published *The Theory of the Leisure Class*, adding a note of moral disapproval of such "conspicuous consumption" as expensive decor. Veblen specifically cited "carpets and tapestries, silver table service," along with silk hats and precious stones, as objects we buy and display "on the ground of an invidious pecuniary comparison."

In the ballroom of the 1715 Villa Palagonia, in the Sicilian town of Bagheria, mirrors set into the walls and ceilings give distorted reflections of the dancing below. *(Photograph: author)*

Some materials are inherently decorative, such as the black walnut chosen for a tabletop by the craftsman Sam Maloof. *(Photograph: Jonathan Pollack, courtesy Kodansha International)*

In 1892, the year his Charnley house and Schiller Theater Building were finished in Chicago, Sullivan suggested that "it would be greatly for our aesthetic good if we should refrain entirely from the use of ornament for a period of years in order that our thought might concentrate acutely upon the production of buildings well formed and comely in the nude," but it was a prohibition he never applied to his own work.

In 1908 Sullivan's disciple Frank Lloyd Wright, who had worked on the Charnley house and who was himself not famous for plain surfaces, also spoke out against overdecoration: "An excessive love of detail has ruined more fine things from the standpoint of fine art or fine living than any human shortcoming. Too many houses, when not little stage settings or scene paintings, are mere notion stores, bazaars or junk shops. Decoration is dangerous unless understood thoroughly, unless you know that it means something good in the scheme as a

whole, for the present you are better off without. Merely thąt it 'looks rich' is no justification for the use of ornament."

Walter Pater, the great prose stylist of a century ago, raised similar objections to "removable decoration" in writing: "The otiose, the facile, surplusage: why are these abhorrent to the true literary artist, except because in literary as in all other art, structure is all-important, felt, or painfully missed, everywhere?—that architectural conception of work, which foresees the end in the beginning and never loses sight of it."

Decoration was seen as an unfortunate disguise of materials as well as of structure. Certainly it is true that some materials, left plain, are inherently decorative, having, in Ruskin's words, "ingrained ornament." As Ruskin says of marble, its "surface receives in its age hues of continually increasing glow and grandeur; . . . its undecomposing surface preserves a soft, fruit-like polish forever, slowly flushed by the maturing sun of centuries." And Christian Norberg-Schulz, in "Timber Buildings in Europe," recalls "how as a child I played on the wooden floor. The wide boards were warm and friendly, and in their texture I discovered a rich and enchanting world of veins and knots. I also remember the comfort and security experienced when falling asleep next to the round logs of an old timber wall, a wall which was not just a plain surface, but had a plastic presence like everything which is alive. Thus sight, touch and even smell were satisfied, which is as it should be when a child meets the world."

But because it is unfortunately commonplace for us to want more

Elevation study for the library of Flete House, Devonshire, as rebuilt 1877–83 by Richard Norman Shaw. Much of the ornamental detail was by Shaw's assistant at the time, W. R. Lethaby. *(Courtesy British Architectural Library/RIBA)*

than we can afford, it has been commonplace throughout the history of interior design for humble materials to imitate grand ones. The revered Palladio used stucco in lieu of stone, and many of the ornate moldings framing his precisely proportioned rooms were painted rather than built. In our Federal period (and consequently in modern revivals of that period) rare marbles were rare indeed, their effects imitated by the technique of scagliola. And veneers of exotically grained woods give us furniture effects that would be impracticable in solid wood.

We must also admit that it is foolish and futile to insist that the materials we employ in our interiors always look natural. Some of our most useful materials—plastic laminate, for example—simply have no inherent natural appearance. We may abhor a plastic surface that pretends to be wood, but we cannot say that purple laminate is less natural than white, nor a pattern of boomerang shapes less natural than a solid color. The appearance of such man-made materials is necessarily artificial, and it is the role of the designer to specify the particular artifice wanted for each application.

These admissions aside, however, we should consider the dangers of fakery: we do not like our interiors to trick us. There are benign illusory effects, to be sure, such as frescoed ceilings, but these are not seriously intended to mislead. When we are fooled by sham construction, by imitation materials, by plastic plants, by fireplaces without chimneys or by windows without views, we are naturally resentful.

Short of our reactions to these direct misrepresentations, there are the frustrations we feel when faced with indeterminacy, when it is not possible for us to know how large a room is or what a table is made of. As Texas architect Michael Benedikt has written in an eloquent book, *For an Architecture of Reality*, which begs for the real in design rather than the eccentric, the ephemeral and the self-consciously symbolic, "The term 'ticky-tacky' expresses well not only our disdain for the (supposed) cheapness of a material, but our defeat at identifying it."

Comparable to the ill effects of fakery and indeterminacy are those of confusion. An unskilled designer may unintentionally deceive us simply by sending too many messages. To quote Bachelard yet again, "Over-picturesqueness in a house can conceal its intimacy."

So, in the case of this last notion, we must concede that the modernist reformers had a point: overdecoration can confuse, over-stimulate and fatigue us. In *Behind the Picture Window*, Rudofsky put

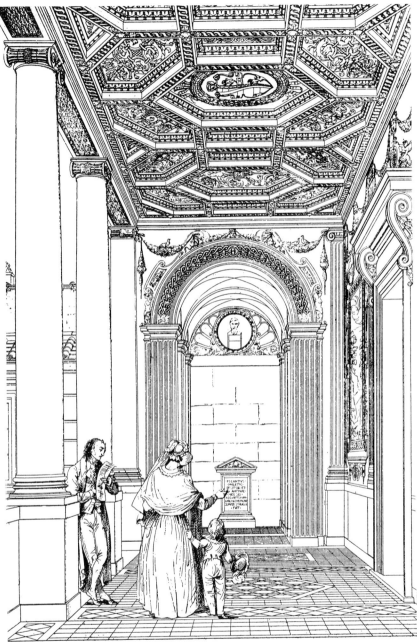

As Robert Woods Kennedy has pointed out, Paul Letarouilly's
nineteenth-century etching of the loggia of Peruzzi's sixteenth-century
Palazzo Massimo alle Colonne, Rome, relates family members to archi-
tectural elements that represent them: the man to the column, the
woman to the arch, the child to the tiny aedicule. *(Courtesy the Library
of the American Academy in Rome)*

it this way: "An innately vacant room never breathes the sort of tired-ness peculiar to our well-furnished ones."

But in other respects, the modernist tirade against ornament no longer convinces us. For one thing, even modern design was never free of decoration. Mies van der Rohe himself, the most austere of the masters, employed materials that were both ornamental and opulent: primavera wood and Roman travertine in the Farnsworth house, doré onyx and curved ebony in the Tugendhat house, onyx again and green Tinian marble in the Barcelona pavilion, bronze cladding the Seagram Building.

And Frank Lloyd Wright, despite his earlier warnings against overdecoration, wrote in *An Autobiography* of 1932 that "expressive changes of surface, emphasis of line, especially textures of materials or imaginative pattern may go to make facts more eloquent—form more significant. Elimination, therefore, may be just as meaningless as elaboration, perhaps more often so."

He also discussed the principle that ornament as well as basic form should be suitable to the material being formed or ornamented. "I now learned to see brick as brick," he wrote, "to see wood as wood, and to see concrete or glass or metal. See each for itself and all as themselves. Strange to say, this required greater concentration of imagination. Each material demanded different handling and had pos-sibilities of use peculiar to its own nature. Appropriate designs for one material would not be appropriate at all for another material."

If it is true that decorative elements are found even in the works of the modern masters, it is also true that, in a more fundamental sense, it was never possible for the modernists to banish decor. Smooth white plaster for enveloping walls is not the absence of decor; it is the choice of one particular, relatively neutral decor. It is a plain style, but it is still a style; a simple look, but still a look. "Whitewash is extremely moral," it seemed to Le Corbusier in 1925, but for us today the decision to paint a wall white is no more moral than the decision to stencil it. The designer's duty to choose among the avail-able wealth of decorative effects for those most appropriate to the job at hand is one that cannot be abdicated, and the functional revolution that would relieve the designer from making nonfunctional choices has not yet come.

Sometimes a room's structure visually dominates the decor, without need of further ornament, as in Antoni Gaudi's Güell crypt near Barce-lona. *(Photograph: author)*

While it is true that decorative elements in our interiors are purely at the service of our pleasure, that pleasure will be better served if the designer is sensitive to the sometimes subtle connotations of ornaments and patterns; they all come with histories. And those histories, if carried back far enough, tell of times when what today is merely decorative had serious uses. The illustrated pattern incised on bamboo from the Malay peninsula, for example, is not a random arrangement of chevrons and zigzags, but was originally (according to A. C. Haddon, as quoted by Archibald Christie in *Pattern Design: An*

**From the Malay peninsula, a meaning-laden pattern used as a charm against skin disease.** *(After Christie,* Pattern Design*)*

*Introduction to the Study of Formal Ornament)* a design with specific references, the lowest level of pattern representing a row of frogs on a river bank, the one above it ant hills, and, above that, vines climbing upward to the foliage of a tree; and the total of these references had a medicinal function: they constituted a magic charm against certain skin diseases.

**Ceiling and pendant lighting fixtures of Bruce Goff's 1930 remodeling of a convention hall in Tulsa. Air-conditioning grilles are gilded, and acoustic tiles are painted green, blue, white and gold.** *(From David G. De Long,* Bruce Goff: Toward Absolute Architecture, *courtesy David G. De Long)*

In other primitive civilizations, decor had an informational function, marking household implements, weapons and tools as the property of individuals or tribes, telling of their society's history or structure, or referring to religious or astronomical events. (This informational function is still performed today, quite overtly, by those who monogram their towels and, more subtly, by everyone who chooses visible possessions.) As Christie suggested, these primitive uses are our inheritance, even the most abstract of our contemporary patterns "growing out of deliberate efforts to present visually all kinds of useful knowledge and mystical lore."

Such knowledge and such lore have often been inextricably entwined in the history of design. The *Mayamata*, the venerable Hindu guide to the art of building, which has been compared to the even earlier architectural rule books of Vitruvius, is at once a *Graphic Standards* of the craft of construction and a religious text, prescribing not only practical but also astrological and ritualistic dicta for finding a building site, orienting a building, planning, erecting, decorating and finally dedicating and entering it.

W. R. Lethaby wrote at length about the connection between design and magic in his *Architecture, Mysticism and Myth* and his later *Architecture, Nature and Magic*. From the conclusion of the later book: "All the arts had their origin in efforts to satisfy the needs of the body and mind, and for long in the youth of the world the mind was deeply immersed in magic. It seems clear at first sight that such a practical art as building developed in the main in response to bodily need, but even this may be doubted. Without the stimulus provided by theories of magic man might have been content with the bare satisfaction of very simple needs; the impetus of magic wonder and the desire to control nature were required to urge him forward to great tasks. Ideas of sharing the permanence of the universe by correspondence, in form and ceremonial, by size and by accuracy of workmanship, pointed the way. The greater buildings were not only for ritual purposes, but they themselves were embodied magic."

Wilhelm Worringer, whose *Form in Gothic* considered the idea of "the latent Gothic before true Gothic," expressed the early use of ornament in a way slightly different from, but not inconsistent with, Lethaby's view. Primitive man, he thought, in ornamenting his buildings and objects, "seeks to stabilise in his perception those individual objects or impressions of the outer world which have a special meaning or value for him, and which are escaping him in the shifting turmoil of his unreliable visual impressions. Out of these, too, he

attempts to create symbols of inevitableness . . . and reduces their varying modes of appearance to certain decisive and recurrent characteristics."

Very similar is the attitude that Pater ascribes to the Roman emperor Marcus Aurelius, an urge "to perpetuate, to display, what was so fleeting, in a kind of instinctive, pathetic protest . . . against the 'perpetual flux' of all things."

Ornament not only records man's awareness of the world but also of man's own self, "darkly reflecting," in Joan Evans's words—and it is important to note that she did not say "clearly reflecting"—"darkly reflecting the web of man's thought and feeling."

Following these physically and psychologically utilitarian origins of ornament, there has, of course, been much development in our communication skills, and by gradual steps ornament has been relieved of its former duties. One of these steps was the invention of writing, with ancient scribes, as Christie describes the process, "leading informative devices through the labyrinthine mazes of pictograph and hieroglyph towards the alphabet," while simultaneously "the painter and the sculptor were discovering and experimenting with the special possibilities inherent in representative art."

Another element noted by Christie in the evolution of ornament is mimicry. It is this impulse, he says, that "bade metal-workers in the Bronze Age set upon the sockets of their axe-heads lines imitating the binding-thongs with which their ancestors in the Stone Age had secured their tools to the hafts." It is this same impulse, he complains, that has produced such vagaries as "false masonry joints . . . ruled upon plastered walls, linoleum floor coverings printed with Oriental woven-carpet patterns, and blue and white tile wall-papers."

But the same impulse is also responsible for positive development, leading the Greek sculptor-architects, and the Egyptians before them, to mimic in stone the temple constructions that earlier had been built of wood and reeds. Sir W. M. Flinders Petrie, the turn-of-the-century scholar of Egyptian art and architecture, believed that "the essential feeling of all the earliest work is rivalry with nature." Most prominent among imitated plant forms, for the Egyptians, was the lotus, associated with the ebbing of the annual Nile flood and the consequent springing up of crops, a motif, according to Flinders Petrie, "so widely spread that some have seen in it the source of all ornament." Indeed, the stylized lotus design was adopted by the Assyrians; in Buddhist countries, it came to be associated with Buddha himself, often shown seated on a lotus; and it was transformed into the fleur-de-lys of me-

An Assyrian stone panel, sixth century B.C., carved in a lotus motif.
*(After Christie,* Pattern Design*)*

dieval heraldry. Lethaby points out that "lotus patterns appear in great profusion on early Greek pottery . . . and in temple decorations; without doubt they had protective virtues. The carved moulding, which we elegantly call 'egg and tongue' and repeat without meaning by hundreds of miles was a lotus pattern and was of good omen."

Not all decorative elements have such specific origins, of course. Here, in *The Decline of the West,* is Spengler with a much more general sort of attribution: "The character of the cathedral is that of the forest, the transformation of columns into clustered piers that grow up out of the earth and spread on high into an infinite subdivision and interlacing of lines and branches; the giant windows by which the wall is dissolved and the interior filled with mysterious light—these are the architectural actualising of a world feeling that had found first of all its symbols in the high forests of the Northern plains."

Nor can the designer be expected to trace the history of every decorative motif; much of such knowledge is, after all, lost to us. The designer can only be aware that what is now a wavy stripe may once have signified water, what now a round disk the sun, and know that mankind, in its evolving sophistication, has not grown completely deaf to the sounds that once told such a clear story.

E. H. Gombrich's *The Sense of Order: A Study in the Psychology of Decorative Art* quotes Edward Burnett Tylor: "Looking round the rooms we live in. . . . Here is the 'honeysuckle' of Assyria, there the fleur-de-lis of Anjou, a cornice with a Greek border runs round the ceiling, the style of Louis XIV and its parent the Renaissance share the looking-glass between them. Transformed, shifted, or mutilated, such elements of art still carry their history plainly stamped upon them;

and if the history yet farther behind is less easy to read, we are not to say that because we cannot clearly discern it there is therefore no history there."

Beyond this awareness of historical significance, the designer must also be acutely aware of the visible characteristics of decorative elements. Oscar Wilde spoke of "mere colour, unspoiled by meaning," and we must not become so concerned with implications and significances that we are blinded to the more obvious aspects of ornament. In an important book, *The Shape of Time*, art historian George Kubler has written: "We are discovering little by little all over again that what a thing means is not more important than what it is; that expression and form are equivalent challenges to the historian; and to neglect either meaning or being, either essence or existence, deforms our comprehension of both."

Receptive, then, to physical evidence as well as to its history, the skillful designer takes care to choose patterns that have an inner consistency or, as Christie suggests, a coherent rhythm, the "posturings, runs, staccato punctuations, strong and weak alternations" of patterns being "calculated effects designed to appeal directly to a rhythmic sense, normally so dormant that it is more by the breach than by the

**Ornament based on nature: an English chair carved in tree-limb and vine motifs.** *(From Harold H. Hart, ed.,* Chairs Through the Ages, *New York: Dover)*

observance of its subtle canons that we are aware of its reactions. Rhythmic effect is the primary aim of all formal ornament; however successful a pattern may be in other respects, if it strikes anywhere a false rhythmic note, its case is hopeless."

And this rhythmic sense, too, is primitive in origin. "Rhythm," the English poet Humbert Wolfe said, " . . . is an echo of bare and barbaric feet in a forest clearing, and rhyme the chuckle of bones beaten in a savage dance."

Ornament's history as charm, totem and message is most easily understood when we consider ornament based on natural forms. Ornament is endlessly commenting on the natural world, sometimes in the form of abstractions from nature, sometimes in literal imitations of cabbage roses, ferns, bunny rabbits or human figures. As Joan Evans maintains, this tendency is not an unsophisticated one. It is not accurate to assume that plant and animal forms represent "the inevitable reflection of a rather primitive civilization in which, to use the hallowed phrase, men lived close to nature. The exact opposite is in fact the case: such naturalistic decoration is produced in courtly civilizations in which men live in surroundings urban enough for distance to lend enchantment to their view of nature. It is in isolation that the bough, the flower, or the living creature have their greatest decorative value; and how rarely does one who lives in purely natural surroundings see them isolated! He lacks the open door, the reflecting pavement, the margined window, the simplified background of wall, that isolate and enhance the single elements of natural beauty for the civilized man, and that by framing turn it half-way into a work of art. . . . [N]aturalism is a growth of urban civilization."

A special case of ornament based on natural forms is ornament based on man. We have already discussed the fact that, in furniture design, structural support is often analogous to the work done by the human body, and occasionally that analogy becomes explicit. Relative here is the fact that ornamental forms may vary, from period to period, as man's view of himself, also expressed in his clothing, changes. In *Style in Costume*, James Laver, Keeper of Prints and Drawings at the Victoria and Albert Museum, compared dominant features of dress with features of architecture and interior design of the same time,

**Structural support is analogous to work done by the human body; in some pieces of furniture, as in this ebony cabinet with tortoise-shell inlay, thought to be an early work by Boulle, this analogy is made explicit.** (*The Wallace Collection, London*)

showing how Elizabethan trunk hose looked like Elizabethan table legs, how ladies' gowns and lamp shades of 1895 were similarly frilly and complex, and how "fontanges," towering women's caps, resembled William and Mary chairs at a time when "the windows of houses, the shapes of furniture, particularly the backs of chairs, showed a similar vertical elongation."

Here we enter the realm of fashion, and it must be admitted that ornamental features, like clothing, are susceptible to cycles of taste. Peter Thornton, in *Authentic Decor*, argues that there is such a thing as "the period eye," a taste that prevails at any period, sometimes craving elaborated surfaces and richly filled rooms, at other times preferring the spare and plain; and Stephen Calloway of the Victoria and Albert, in his book *Twentieth-Century Decoration*, speculates that the development of photography, for example, may have brought about a taste for an increased density of detail in nineteenth-century interiors.

British art critic Roger Fry wrote a brief essay, "The Ottoman and the Whatnot," in 1919, a year when there was a revival of interest in the style of the 1880s. "And now," he said, "having watched the What-

The delicacy of ornamental inlay on a Hepplewhite dressing table, c. 1775, is entirely sympathetic to the character of its structure. *(Victoria and Albert Museum)*

A Rococo alcove, c. 1730–35, attributed to Antoine Vassé. The curved corners of the room, the curves of the gilded and painted oak moldings, the lines of the chairs and chests—all are consistent with the decorative concept. *(The Metropolitan Museum of Art, gift of J. Pierpont Morgan, 1906)*

not disappear, I have the privilege of watching its resurrection. I have passed from disgust, through total forgetfulness, into the joys of retrospection." This sort of temporary vogue has nothing to do with intrinsic artistic worth, of course, but with the unrelated pleasures of conjuring up images of the past, and usually of highly romantic images at that. "Whoever handling a Louis XV *tabatière*," Fry asked, "reflected how few of the friends of its original owner ever washed, and how many of them were marked with smallpox? The fun of these historical evocations is precisely in what they leave out."

Whatever they leave out, they include valuable information as well. Joan Evans again: "We take patterns too much for granted. We should learn to plunge our minds into them, as we do into the sea of

poetry, and to receive as sharp an impression of an age from its orna-
ment as we do from its literature."

But what of the vast body of ornament based not on natural forms
but on geometry? Even some of these may be abstractions from nature,
but some instead are mere cerebral inventions. Particularly in Islamic
countries, with their religious proscriptions of representative art, the
inventiveness of geometric decoration is impressive. And it is, per-
haps, in this field that the future of ornament is most unknown and
most promising. For we have taught our computers to devise geomet-
ric ornament for us, and no one among us yet knows what they will
produce. Whatever it is, it will still be the task of the designer, and far
from the least important task, to select a decor.

# COLOR AND LIGHT

•

W HAT IS THE USE," asked Alice, "of a book without pictures
or conversations?" And what is the use of a book about interior
design without a plenitude of pictures in color? For it is true that color
is of the essence of any interior design. A work of architecture, stand-
ing in the open air and direct sunlight, may convey the most important
part of its message by its highlights and shadows, which, even in a
black-and-white photograph, reveal its massing. But an interior,
bathed in softer lighting of our own devising, offering close contact
with its containing surfaces and contained objects, is experienced
largely through its tints and textures. Scientific studies have been
made (although one would suppose them hardly needed) to prove that
the same room is perceived differently when its lighting is changed;
we would expect similar results when its colors were changed.

John Locke made a distinction between the primary and second-
ary qualities of objects, their primary qualities of size and shape being
objectively perceived, relatively independent of individual sensibili-
ties, but their secondary qualities of color, texture, sound, and smell
being perceived in a highly subjective way. In Ruskin's words, "Light
and shade, then, imply the understanding of things—Colour, the
imagination and sentiment of them." In the intimate realm of interior
design, imagination and sentiment are fully as important as under-
standing, so that a sense of color—for Ruskin, "the sacred sense"—is
as important for an interior designer as for a painter.

111

Even so, color photography in a book such as the present one might distract us from the subject, for we are not concerned here with recommending to the designer any particular color combinations or lighting effects. Freed from the task of illustrating designs to be emulated, our illustrations here can do their work in black and white; the color supplied by the reader's inner eye will be enough.

Like all other elements of interior design, color communicates, carrying messages about design intent from the designer to the user. As in any kind of communication, too many simultaneous messages can be confusing. Edith Wharton and Ogden Codman, Jr., advised that "the fewer colors used in a room, the more pleasing" the result would be. "A multiplicity of colors produces the same effect as a number of voices talking at the same time. The voices may not be discordant, but continuous chatter is fatiguing in the long run."

That much is obvious. Much less clear, however, is the relationship between colors and their messages, for the manner in which colors communicate varies as the context of the communication varies. Bright red is generally exciting, certainly, and soft blue generally restful, but such correlations are neither precise nor consistent. E. H. Gombrich, in a 1952 essay: "Red, being the colour of flames and of blood, offers itself as a metaphor for anything that is strident or violent. It is no accident, therefore, that it was selected as the code sign for 'stop' in our traffic code and as a label of revolutionary parties in politics. But though both these applications are grounded on simple biological facts, the colour red itself has no fixed 'meaning'. A future historian or anthropologist, for instance, who wanted to interpret the significance of the label 'red' in politics would get no guidance from his knowledge of our traffic code. Should the color that denotes 'stop' not stand for the 'conservatives' and green for the go-ahead progressives? And how should he interpret the meaning of the red hat of the cardinal or the Red Cross?"

Ludwig Wittgenstein spent the last eighteen months of his life considering the philosophical implications of color. Clear throughout his writings (gathered together as *Remarks on Colour*) is his conviction of the inconstancy of colors' meaning. "The colour of a blood-

Manipulation of both natural and artificial light in a stairwell of Fumihiko Maki's Municipal Museum of Contemporary Art, Kyoto: The lighting fixture disports itself as sculpture while, beyond it, translucent panels temper the sunlight and only a narrow strip of clear glazing reveals the view. *(Photograph: author)*

Bruce Goff's Hopewell Baptist Church, 1948, near Edmond, Oklahoma: Constrained by budget, Goff has made the hanging light fixtures from aluminum cake pans; they are nevertheless effective in the space. *(From David G. De Long,* Bruce Goff: Toward Absolute Architecture, *courtesy David G. De Long)*

shot eye might have a splendid effect as the colour of a wall-hanging," he wrote in one passage, and in another, "A colour which would be 'dirty' if it were the colour of a wall, needn't be so in a painting." Then again, "One and the same musical theme has a different character in the minor than in the major, but it is completely wrong to speak of the minor mode in general. (In Schubert the major often sounds more sorrowful than the minor.) And in this way I think it is worthless and of no use whatsover . . . to speak of the characteristics of the individual colours. When we do it, we are really only thinking of special uses."

The meaning of color varies not only with changes of location and

use, but also with changes in time. While not nearly so susceptible to fashions of the moment as some sensation-seeking publications would have us think, taste in color does evolve and develop. Particular color palettes have been associated with historic periods, with regions, with decades, and even with specific designers. English architect and designer M. H. Baillie Scott was fond of saying, "When in doubt, whitewash," and, similarly, Elsie de Wolfe, who called herself America's first woman professional decorator, worked with the slogan "plenty of optimism and white paint."

A surfeit of white surfaces is also attributed to the pioneers of modern architecture, although this attribution is, at best, an oversimplification. Mies's Barcelona Pavilion was punctuated with strong color, and his 1927 silk exhibition in Berlin, designed in collaboration with Lilly Reich, had fabric walls of black, orange and red velvet and of black, silver, gold and lemon-yellow silk. Marcel Breuer was adept at juxtaposing expanses of natural wood or natural stone with panels of vivid primaries, as well as with a milky cobalt that came to be known as "Breuer blue." And Le Corbusier, even though he wrote that "as early as 1910, I knew about the bracing quality of chalk white," immediately added, "Practice showed me that the joy of white explodes only when surrounded by the powerful hum of color." C. Ray Smith has chronicled how, in the mid-1950s, modernism was further enriched "by the sensuous colors of the color-field school of Abstract Expressionism," and how, about 1968, a briefly popular "psychedelic" style "espoused the whiplash curve of the popularly rediscovered Art Nouveau, but expressed it in phosphorescent colors called Day-Glo."

The brilliantly colored hangings of the silk exhibition café, Exposition de la Mode, Berlin, 1927, by Mies van der Rohe and Lilly Reich.

Billie Tsien's drawing "The Room You See Before You Sleep" expresses the nature of rooms at night, often forgotten in daylight. *(Courtesy Billie Tsien, from Tod Williams and Ricardo Scofidio,* Window, Room, Furniture*)*

The vehicle of color is light. Our response to color is affected not only by its contexts of place and time, not only by our own perceptual mechanisms, habits and tastes, but also by the light in which it is seen. Wittgenstein suggested a test: "Look at your room late in the evening when you can hardly distinguish between colours any longer —and now turn on the light and paint what you saw earlier in the semi-darkness. How do you compare the colours in such a picture with those of the semi-dark room?"

Vision fails completely in the absence of light and also in excessive glare. Between these two extremes is a wide range of lighting levels, each providing its own level of visual efficiency and comfort. And at each level there is an almost infinite choice of lighting qualities and effects. The interior designer has many choices to make, concern-

ing not only how to make a design visible, but also concerning which aspects of its character to emphasize. Aspects of a lighting scheme to be considered include the character and color of the light to be used, the illumination of vertical and horizontal planes, the highlighting of selected objects, the gradation of shadows, the use of silhouetting effects and, in general, the choice of an appropriate level of drama.

The technical achievement of the chosen effects is frequently best left to a lighting consultant, but the designer who does not participate in the choice of effects abdicates a major role. These effects must be not just for optimal or average conditions; they must take into account all seasons, all weathers, all times of day and night, all possible uses to which a room might be put, and all the likely moods of its users. The designer must anticipate that sunlight will not always stream through a skylight—without artificial light, it will appear as a black hole in the ceiling when the sky is dark—and that we will not always sleep soundly throughout the night in a darkened room—in many cases, a dim night-light is an asset; in most cases, some effects more subtle than we could appreciate in daylight will be wanted.

Color and light, though their exact effects are troublesomely subjective, are key elements in any design. Like any other, they must be

**In a bedroom designed by George Ranalli, a polished brass canopy reflects and colors the light from two small sconces.** *(Photograph: George Cserna)*

planned to reinforce the main concept. Planned correctly, they can illuminate that concept not only literally but also in terms of giving or withholding emphasis. As Schopenhauer wrote in *The World as Will and Representation*, "The presence of light is an absolute condition [for our appreciation of design] . . . more than others, it augments what is beautiful . . . ; it even bestows the greatest beauty on that which is most insignificant."

A factor that modifies our experience of both color and light is texture. Our haptic sense is not directly involved: unless we are blind, we do not actually feel our way about a room. But our optic sense tells us how materials in a room will feel when we touch them (in Kahn's words, "to see is only to touch more accurately"), and this knowledge helps determine our responses. In *The Language of Vision*, Gyorgy Kepes points out that "the particular rhythm of light and dark that makes up visible texture is beyond our ability to distinguish in any form of visual organization in terms of modeling by shading. It has a fine grain of sensory impact which can be comprehended only in its structural correspondence to other sensory feelings. The surface texture of grass, concrete, metal, burlap, silk, newspaper or fur, strongly suggestive of qualities of touch, we experience visually in a kind of intersensory blend. We see, not light and dark, but qualities of softness, coldness, restfulness—sight and touch are fused into a single whole."

Color and light and, perceived through them and modifying their effect, texture—all three of these are elements to be used by the designer in working toward a desired effect. Rasmussen suggests that it may be more effective to use them as reinforcement of existing room character than to use them as a corrective or palliative measure: "Instead of trying to make the cool rooms warm it is possible to do just the opposite by employing colors which emphasize their cool atmosphere. Even when the sun is warmest and most brilliant, daylight in northern rooms will have a blue undertone because all light here is, after all, solely and exclusively reflection from the sky. Blue and other cool colors show with great brilliance in northern rooms while warm colors show up poorly, as if seen under a lamp which sheds a bluish light. Therefore, if in northern rooms cool colors are used and in southern rooms warm colors, all of the colors will sparkle in their full radiance."

In *The Grammar of Ornament*, first published in 1856, Owen Jones proposed a similar reinforcement when color is applied to three-

dimensional ornament: "In using the primary colours on moulded surfaces, we should place blue, which retires, on the concave surfaces; yellow, which advances, on the convex; and red, the intermediate colour, on the undersides." Never mind that most color theorists would say that red "advances" more than yellow or that the designer may not always want to emphasize existing profiles; the point is that colors, like light and texture, are to be used with purpose, not arbitrarily. They are never independent of the other elements of a room.

# SOUND AND SMELL

I T IS NOT WHOLLY through our senses of sight and touch that we apprehend interiors. The designer needs to be sensitive as well to the sound of a room and even to its odors.

Rasmussen's *Experiencing Architecture* closes with a chapter called "Hearing Architecture." Its first illustration is a film still of "the endless underground tunnels of Vienna's sewer system," scene of a gangster hunt in the 1949 film *The Third Man*. The picture instantly suggests the drip of water from the concrete vaults and the echoes of running feet, and it makes the point very well that many interior spaces are strongly characterized by the sounds we hear in them. (The image may also bring to mind how such a space might smell.)

Reverberation times and other acoustic characteristics are critical, of course, in concert halls, theaters and opera houses. In church interiors, they have brought into being manners of speaking (so that the sermon would be comprehensible) and whole styles of composing, from Gregorian chants to polyphonic music. In our own time, restaurant design is especially concerned with how rooms sound, a noisy room connoting conviviality and popularity, a quieter one presenting a more sedate image. Even residential design is affected by sound: The hard surface typical of an entrance foyer is not only practical for purposes of maintenance, but the noise of footsteps there clearly suggests a space that is more public than the well-carpeted living room beyond.

The suggestions made by sound are subtle ones, however, and can be overridden by more powerful factors. Not only is the residential

foyer likely to be tiled, for example, but so is the bathroom, yet in this last case we have no impression of a public area, but rather, because of the bathroom's functions, of a very private one.

Rasmussen made an interesting case for acoustic variety and also for acoustic verity, the appropriateness of a room's sound to a room's visual character. Although he acknowledged great advances in the manipulation of acoustics, he thought this knowledge was put to poor use. "Too much interest has been given to these easily attained effects," he said. "The favorite interior of today seems to be something so unnatural as a room with one wall entirely of glass and the other three smooth, hard and shiny and at the same time with a resonance that has been so artificially subdued that, acoustically speaking, one might just as well be in a plush-lined mid-Victorian interior. There is no longer any interest in producing rooms with differentiated acoustical effects—they all sound alike. Yet the ordinary human being still enjoys variety, including variety of sound."

More subtle still than our sense of sound is our sense of smell, yet it too conveys some information about interiors. Not much is done, as a rule, to give our rooms a scent, other than the occasional provision of a bowl of potpourri. Yet one luxurious hotel in Marrakesh has on its staff a full-time *parfumeur*, who has devised an individual scent for each of the major public rooms, maintained by means of specially blended oils.

In the past, when protection against foul odors was more an issue than it is today, such practices were more common. A curious custom that lasted well into the sixteenth century, according to Braudel, "was to cover the floors of the ground-floor rooms and the bedrooms with straw in the winter and herbs and flowers in summer." Thus in 1613 a physician prescribed the scattering of herbs "in a handsome room, well-matted or hung with tapestries all round and paved below with rosemary, pennyroyal, oregano, marjoram, lavender, sage and other similar herbs."

Smell is not unrelated to our other senses, and the designer needs to deal with connotations and associations as well as with more direct information. Rasmussen noted that "not only are cigars brown but their containers are made of brown wood, cedar or mahogany. . . . But

In Sir Carol Reed's 1949 film *The Third Man*, the closing scenes in the tunnels of Vienna's sewer system evoke the distinctive sounds—and even the smells—of that environment. *(Courtesy The Museum of Modern Art Film Stills Archive)*

regardless of how cigars are packed, we cannot imagine them in pink or mauve containers. We think of these colors more in connection with soap and perfumes, and they recall odors that are inimical to tobacco. We associate certain colors with masculine or feminine attributes. Thus, 'tobacco' colors are suitable for the study, 'perfumed' ones for the boudoir."

Smell is not, it must be admitted, a major weapon in the designer's arsenal. But to whatever extent odors are detectable in an interior, it is not beyond the designer's province to assure that the odors are appropriate. A restaurant is not to smell of motor oil, nor a garage of baking bread; a billiards room is not to smell like a florist's shop, nor a corporate board room like a beer hall. It should hardly need mentioning that the welfare of users demands that all interiors be free of products that emit unpleasant or noxious fumes.

# ART

THE INTRODUCTION OF ART alters a room radically. A painting hung on a wall transforms that wall more than wallpaper does, as much as a mirror does, almost as much as a window or door does. Art exercises a magic that deserves to be used sparingly and with care.

The introduction of art can also alter a design concept radically, requiring from the designer definitions and distinctions between design, craft and fine art, between unique art works and mechanically reproduced ones, between single art works and collections, and between the art work that is in the room and the art work that *is* the room.

Distinctions between design, craft and fine art are based on judgments of quality, seriousness of intent and rarity. The designer needs to make these judgments because each category will suggest its own use, its appropriate frame or pedestal or niche, its proper lighting treatment, its degree of isolation, its prominence in the total scheme. Such decisions, of course, are to be made not on the basis of the cash value of a work but on its artistic worth, its intrinsic quality, and also on its relationship to its context, the degree of its potential reinforcement of the design concept.

The word "design" is used here in the sense of something distinct from craft or art; it indicates something that is very literally applied to a room, such as murals, frescoes, decorative stenciling, ornamental plaster work, stained glass windows or wallpaper.

In the extension to the music room of Pencarrow, Cornwall, added about 1930, the marble Venus stands comfortably and well lighted in her elegant pinewood alcove; the two chairs, however, are placed where no one would want to sit and are inappropriately displayed as art works. *(Courtesy Mrs. J. A. Molesworth-St. Aubyn)*

The distinction between craft and fine art is more controversial. One generally accepted difference is that an art work is conceived freshly by the artist; it is unprecedented. The work of craftspeople, however, while prepared by hand in each instance, may owe its form to a longstanding tradition. One wicker basket may itself be unlike any other, but the idea it attempts to present in physical form is the same idea that stands behind generations of basket-making.

Another difference between art and craft, one that may have greater effect on the designer's treatment of the object, is that the emotional content of art is greater than that of craft. British critic Peter Dormer, author of *The New Ceramics* and *The New Furniture*, says that the craftsperson "is not expected to generate new insights into the world or to construct brilliant metaphors. Rather than lead the avant garde in art we expect craftspeople to use what art had discovered in order to embellish, for the pleasure of the rest of us, the home and civic and institutional buildings. . . . We, the consumers, want to be delighted, impressed, surprised and cajoled, but not mystified or subverted. Mystification and subversion we leave to artists

and from them we demand insight and intelligence of a very rare order indeed."

It is an unusually privileged interior that can boast of fine art of museum quality, however. Museums themselves are obvious exceptions; so too, frequently, are some corporation board rooms and executive offices and a few private houses. More usually, interior design will have to be satisfied with works of art that are less than masterworks or with reproductions of great works. On the positive side, the art in interior design may gain in personal appeal what it lacks in publicly acknowledged value: Even if a particular painting is not sought by the Frick Collection, a client may find it emotionally resonant because a relative painted it or because it shows a familiar scene.

While recognizing the potency and validity of these sentimental values, the interior designer must guard against their being used in support of bad art. Which art is bad, which good, will differ, of course, according to the time, situation, and personality to be pleased, but for most of us in most situations, bad art would include, for example, color lithographs of dogs playing poker, crude copies of Dürer's *Praying Hands*, and portraits of little girls with enormous moist eyes— would-be art so debased or overfamiliar that it must drag any interior design to its own level. Similarly, Walter Benjamin has used the phrase "loss of aura" to describe the state of art that is mechanically reproduced in quantity, and Bernard Myers, in a section of Hugh Casson's *Inscape*, has identified a genre he calls "furniture art"—that is, art used as room furnishings or even as wallpaper, denying whatever little

**Furniture calculatedly and appropriately displayed as art objects in a 1978 Chicago showroom design by Powell/Kleinschmidt.** *(Photograph: Jim Hedrich, courtesy Hedrich-Blessing)*

African and American folk art in the New York loft of artist Dennis
Oppenheim. Loft renovation was by Shael Shapiro. *(Photograph: Elliot
Fine)*

artistic merit it might deserve. "Even an 'op' picture which would
blind at close quarters," he says, "can be made to serve as background
for the right kind of receptionist chosen for the colour of her hair."

Fine art is noted for its singularity, and the client-designer team
with rare restraint may conceive a room focusing on one piece of art
alone. More often, however, art works come in numbers or not at all.
Art with great personal appeal for a client (and therefore highly ex-
pressive of the client's personality and taste) is often in the form of a
collection; whereas individual items might seem of negligible worth,
the group as a whole, reflecting a passionate and private enthusiasm,
may have great interest and may deserve prominence in a design
scheme.

In an essay on Louis-Philippe, Benjamin wrote: "The interior is
the refuge of art. The true inhabitant of the interior is the collector.
He takes it upon himself to transfigure things. He assumes a Sisyphus-

like task: to *remove from objects,* by possessing them, *their quality of merchandise.* But he gives them only an amateur's value, not the value of use. The collector not only transports himself, as in a dream, to a distant or past world, but also to a better world, in which . . . things themselves are freed from the servitude of having to be useful."

An acrobatic vitrine of glass and elm displays a collection of artifacts in Harvard University's Woodberry Poetry Room, Lamont Library, designed in 1949 by Alvar Aalto. *(Photograph: Cervin Robinson)*

As in all our attempts at classifying the elements of interior design, we must admit here the existence of hybrids that will not fit neatly into our categories—objects that are or are not art depending on where and how they are exhibited and who sees them (for example, the urinal titled *Fountain* and shown by Marcel Duchamp in the 1915 New York Salon des Indépendants), as well as objects that inhabit middle ground between art and craft, art in the form of rooms and rooms that are art.

One of these rooms was Kurt Schwitters's *Merzbau*, built incrementally in Hannover between 1923 and about 1936, then destroyed in 1943. "As the structure grows bigger and bigger," Schwitters wrote, "valleys, hollows, caves appear [in one of which, reportedly, a dramatically lighted bottle of urine was enshrined; others contained tributes to fellow artists, including Arp, Gabo, and Miró], and these lead a life of their own within the overall structure. The juxtaposed surfaces give rise to forms twisting in every direction, spiralling upward. An arrangement of the most strictly geometrical cubes covers the whole, underneath which shapes are curiously bent or otherwise twisted until their complete dissolution is achieved." This multilevel suite of interiors is itself the art work, growing tighter, ever more constricted, ever more limiting, as, layer upon layer, Schwitters added to it.

Only slightly less demanding as an environment is Mondrian's *Salon de Madame B. à Dresden*, a room designed by the painter in 1926, but not constructed until 1970, twenty-six years after his death. Here, at least, there are vestiges of familiar elements of a room: walls, ceiling, floor, window, door, a chaise (however hopelessly uncomfortable) in the corner, even an oval reference to a small rug (although this last seems due to a misinterpretation, as Nancy Troy has pointed out, for one drawing shows instead a small oval-topped table—actual furniture!). It was Mondrian's hope that, in such rooms, "by the unification of architecture, sculpture and painting, a new plastic reality will be created. Painting and sculpture will not manifest themselves as separate objects, nor as 'mural art' which destroys architecture itself, nor as 'applied' art, but *being purely constructive* will aid the creation of a surrounding not merely utilitarian or rational but also pure and complete in its beauty."

There, of course, is the trouble: noble and inventive as these experiments are, pregnant, too, with cues for further experiments, they

The room as art: Kurt Schwitters's *Merzbau*, built in Hannover, Germany, beginning in 1923; destroyed twenty years later.

The room as art, a second vision: Piet Mondrian's *Salon de Madame B.
à Dresden*, designed in 1926 but not built until 1970. *(Formica on wood,
9 ft. by 12 ft. by 14 ft. Photograph: Ferdinand Boesch, courtesy Pace
Gallery, New York)*

fail as rooms to just the degree that they are pure and complete. Being
whole works of art themselves, there is no opportunity in them for
displaying other art (although it is conceivable that a Mondrian could
be hung in Madame B.'s salon, but certainly not a painting of any
other character); being finished, there is no place in them for a wet

umbrella, a vase of flowers, a magazine or book or glass of wine, no place for a user.

There is also the type of hybrid that occupies the hazy territory between art and decor. Edith Wharton complained in 1902 that "we have no English word to describe the class of household ornaments which French speech has provided with at least three designations." The three French terms were bric-a-brac, bibelots, and objets d'art, and the distinctions between the three indicated to Wharton "a delicate and almost imperceptible gradation of quality." In English, she made her own distinctions, dividing "the different kinds of minor embellishments" into two classes, the first being objects of fine art "such as the bust, the picture, or the vase," and the second being "those articles, useful in themselves,—lamps, clocks, fire-screens, bookbindings, candelabra,—which art has only to touch to make them the best ornaments any room can contain."

Wherever in the three categories of the French or the two categories of Wharton a group of objects may fall, it must be prevented from overwhelming the larger concept of the room that will house it. Personable collections, like personable children, are likely to be attention-grabbers, and sometimes the adults should be alone and a quiet design should be undisturbed. "Pictures deface walls," Frank Lloyd Wright thought, "more often than they decorate them."

Having considered the nature and quality of the art to be accommodated, the designer has a broad range of responses from which to choose. At one end of the range, art may be treated as background, as wallpaper, as a quiet but unimportant visual ornamentation given no particular emphasis by means of lighting or prominence of placement. Some art and would-be art deserves this lack of attention.

(In other cases, deserving art is neglected through carelessness. It is a truism of how-to-decorate texts that a painting should be hung at eye level for best viewing. It should not need mentioning that our eyes are at different levels when we stand, as we normally do in a museum, than when we sit, as we normally do in a living room or office.)

At the other extreme, art can be given the full museum treatment. Brian O'Doherty has written entertainingly of "the white cube" that is today's typical museum or gallery space: "The outside world must not come in, so windows are usually sealed off. Walls are painted white. The ceiling becomes the source of light. The wooden floor is polished so that you click along clinically, or carpeted so that you pad soundlessly, resting the feet while the eyes have at the wall." In such rooms, O'Doherty says, "as in churches, one does not speak in a nor-

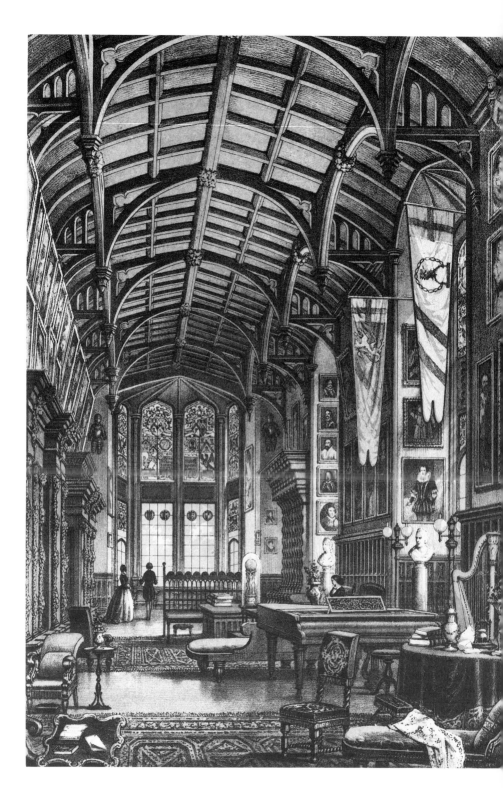

mal voice; one does not laugh, eat, drink, lie down, or sleep; one does not get ill, go mad, sing, dance or make love. . . . This slender and reduced form of life is the type of behavior traditionally required in religious sanctuaries, where what is important is the repression of individual interests in favor of the interests of the group." Supportive as this may be to the contemplation of art, it renders the room inapt for other uses, making even the most worshipful viewer uncomfortable: "Indeed the presence of that odd piece of furniture, your own body, seems superfluous, an intrusion. The space offers the thought that while eyes and minds are welcome, space-occupying bodies are not."

A fine work of art is among our species's highest achievements, and the designer is blessed when one or more of them is a factor in any design. But there are dangers in giving either too little or too much reverence to art. Except in the case of a museum or gallery, where the viewing of art is the sole purpose of a room, respect for art must be secondary to respect for the designer's function-conscious concept. We can live happily with art—some cannot live happily without it—but we cannot live *in* art or even in a "white cube."

Art as wallpaper: In the Long Gallery of Adare Manor, Limerick, designed by A. W. N. Pugin, the location of ancestral portraits betrays the fact that they have been hung for general effect, not meant to be seriously looked at. *(Courtesy Christie's)*

# PLANTS

W E BEGAN THIS BOOK with a reference to a garden as man's original habitat, but it has been a long time since man could safely or comfortably dwell in the open. For most of his history, man's garden has been walled. The Eden of Genesis may have needed no fencing, but the gardens of the Song of Solomon are enclosed, as are the Shalimar Gardens of Kashmir, as is the Alhambra of Granada, as are the Villa Lante and Villa d'Este and Boboli and, indeed, all the wonderful gardens of Italy. Only in the picturesque garden design of the great English country houses do we see a nostalgic reference to nature unbounded.

It is a short step from the walled garden to the garden in a building. The wall brought the garden not only protection but also a sense of privacy, even of secrecy, a sense that is heightened when the garden is buried deep within a palace or an office block or, as at Pompeii, a private house. To be privy to that secret, to penetrate the construction and discover the open space within—a space of sunlight, greenery, the scent of flowers, perhaps the play of water—is one of the most delightful experiences architecture can offer us, an experience at which the present proliferation of atriums aims, however vapid many of them may be.

If the experience becomes commonplace, of course, it loses its power, and the designer should remember that, historically, plants have had only a minor part to play in architecture and its interiors.

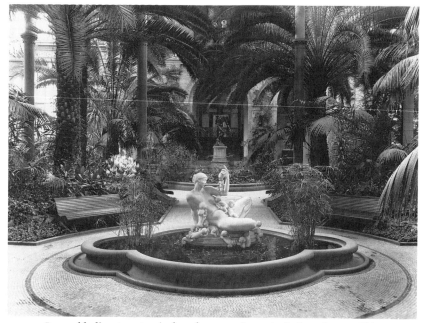

In a cold climate, a tropical garden room is particularly welcome. This one is at the heart of the Ny Carlsberg Glyptotek in Copenhagen.

There was no potted ficus in the Pantheon, no geranium on the stylobate of the Parthenon.

The Victorians, however, were devoted to indoor plants—potted palms flanking the mahogany breakfront, fuchsias blooming on the windowsill, vases of bulrushes and cattails, hanging baskets of Boston fern, fragrant jasmine and heliotrope and, everywhere, the hardy aspidistra. Even so, the Victorian house, excepting an occasional bay window or sun porch or even a conservatory, was dark. When Victorian gloom gave way to modern expanses of glass, when our residential and commercial interiors became places where plants could easily photosynthesize, there was naturally an inherited urge to crowd our interiors with plants. Often, there was an urge to go too far. It could even be argued that a major asset of large glass areas—that they allow the interior privileged views of nature—is antithetical to the practice of lining the inside of the glass walls with plant material. It is easy to ridicule this trend. Flanders and Swann did it tersely in their theatrical revue called *At the Drop of a Hat*:

> We're terribly House and Garden
>  Now at last we've got the chance.
> The garden's full of furniture,
>  And the house is full of plants.

But, used knowledgeably, plants are a potent element in interiors, and, lacking an atrium, a cloister or a courtyard, a designer can use them to provide a small measure of a garden's delight. Plants can bring life to an otherwise static room, and they can engage our eye with a profligate complexity of form (Michel Butor has used the phrase "vegetal inventiveness") that even the most intricate carvings or figured marbles cannot match.

In addition to fascinating form, plants appeal because, like ourselves, they are a living part of nature, and "nature is beautiful," Le Corbusier wrote in *The Decorative Art of Today*, "because it is sentient."

Living plants can also provide, in a small way, the practical service of purifying indoor air. Plant leaves absorb harmful carbon dioxide, and the plant's photosynthetic process, in the presence of light, transforms it into water vapor and oxygen, which are returned to the air. To some degree, plants may even remove from the air small amounts of carbon monoxide, benzene, formaldehyde and other pollutants. While the benefits of this process are negligible in a well-ventilated interior, they may be significant in an office building that, for efficiency in heating and cooling, has been tightly sealed and in which some building materials and synthetic fabrics are emitting traces of undesirable organic chemicals.

In unusual cases there may be an additional appeal to plants in the fact that living things need some nurturing in order to stay that way. E. J. Langer and J. Rodin, in a 1976 study, found that nursing-home residents given plants to care for experienced a heightened sense of well-being; those presented with plants cared for by the nursing-home staff, however, did not.

Plant materials in interiors, special as they may seem, are elements of design like any other, not superfluous to a design concept, but in service to it; their choice and placement should work as an aid in organizing and emphasizing the designer's idea. Appropriate plant size is a fundamental factor in their use, and general plant character another. For cut flowers, a choice must be made between highly stylized and structured arrangements, loose displays of flowers all the same variety and color, or the drama of single stems in slender vases. Color is basic as well, and certainly the designer will consider carefully the relationship between plant material and container. The designer must also be aware of the line between those major plant materials that can be specified during the design process and those that are necessarily left to the choice of the user.

It is important that this irreplaceable decorative element not be trivialized by inappropriate use. The proper role of plants is not remedial. Too often they are used to camouflage awkward areas, to direct traffic, or to fill unusable corners. A cluster of plants under a stair landing or under an escalator may keep people away from conditions where headroom is dangerously low, and a row of plants before a glass wall or edging a pool may keep people from walking into the glass or falling into the water, but these uses seldom delight us. Plants have too much potential value in interiors to be used simply as barricades.

The delight they can bring is also devalued if they are not convincingly alive in their setting. To place a plant that is dependent on sunlight in an area without sunlight is as disturbing as placing a piano with its keyboard against the wall. Constant replacement of unhealthy plants, even when a client can be persuaded to pay for it, is never a convincing substitute for healthy plants; it is tantamount to the shoddy deception of artificial plants.

These last are of many kinds, of course, the most deceptively realistic (and, therefore, the most annoying when we learn we have been tricked) being elaborate silk ones; the most hopelessly unconvincing (and, therefore, the most cheerful) being blowzy paper ones. There are the glass flowers in Harvard's University Museum, which, as Marianne Moore's father noted, superior people never made long trips to see. And there are the wax flowers and fruit kept under bell jars, one of the horrors (it seems today, although they may be due any moment for a revival of popularity) of Victorian decor. (As Oscar Wilde mourned, "The wax peach no longer ripens in the glass shade.")

Arrangements of cut flowers are different, of course. We do not expect them to have a long life and are happy to see them in places live plants could not tolerate. The designer must realize, however, that their transiency makes them a highly undependable element in any composition. Flowers are fine as incidental grace notes, and the designer may reasonably suggest a vase and modest bouquet on each desk of an accounting department or on each table of a restaurant, but an interior that depends for its success on an endless succession of arrangements in a prominent location, all of them the proper size, the

Plant material (bamboo) used as the dominant decorative element in the lobby of Tokyo's Sogetsu flower arranging school. The building design is by Kenzo Tange; lobby water garden design is by Isamu Noguchi; plant material arrangement is by Hiroshi Teshigahara. *(Photograph: author)*

proper character, the proper color (and all of them, certainly, of a proper freshness), is an interior leaning on a fragile crutch.

Yet another matter is the arrangement of dried flowers, retaining many of the visual attributes of living plants and lacking only life. These can entertain the eye for a winter season, but their appeal fades fast as spring brings fresh blossoms.

The use of plant material in interiors, then, is not so different from the use of furniture or the use of art. Its special effectiveness is spoiled if it is treated merely as filler or as a disguise for poor planning, just as the effectiveness of fine antiques would be, or the effectiveness of sculpture. Not that plant material must always be used sparingly; there are appropriate situations, too, for abundance. And when thoughtfully chosen and thoughtfully placed, plants can evoke the bower, the walled garden, even Arcadia.

# DETAILS

THERE ARE TWO THINGS to remember about details: that they have definite character of their own, and that their character should be used to reinforce the overall impression the designer wants a room to make. A design attitude cannot be abandoned once the basic outlines of a design are established; it must also inform the most minute parts of that design if the result is to be coherent. Inappropriate details are as destructive in interior design as clumsy brush strokes in painting or discordant notes in music.

On the other hand, any interior design, beyond an infinitesimally brief first impression, is an amalgam of many ingredients that are experienced individually. Meyer Schapiro, in an essay about works of art in general (not interiors in particular), has said that "to see the work as it is one must be able to shift one's attitude in passing from part to part, from one aspect to another, and to enrich the whole progressively in successive perceptions. . . . [We] do not see all of a work when we see it as a whole." A homely parallel: To be common ingredients in an excellent stew, the carrots need not have the same flavor as the veal. This does not mean that a cook can successfully blend raspberries and asparagus.

There are two types of details in interior design: the type that is part of the constructed fabric of the work and that cannot be removed without some dismantling of that work, and the type that is brought to the work and can just as easily be taken away. Molding around a

Detail of the modern glazing cut to fit older stone profiles at the Pousada dos Loios, Évora, visible in the background of the overall view on page 72: new technology used to maintain as much as possible of the fifteenth-century character. *(Photograph: author)*

window opening or the bracket under a mantel is of the first type; an obelisk on an end table or an ashtray on a desk is of the second type, which we might better call accessories. The first type is shared with architecture; the second is not.

Details of the first type are everywhere, often arising out of the materials or the construction procedures used. Sometimes they make transitions between elements or between surfaces, as joints and corners do; sometimes they conceal flaws or potential flaws, as baseboards cover the cracks where flooring and wall materials meet; sometimes they are visible expressions of unseen conditions, as nonstructural pilasters may represent the actual structure buried in the wall behind; often they merely make lyrical, perhaps poetic, comment, as a plaster ceiling medallion may do; in every case, they contribute character.

Like furniture, details speak in ways that the designer must understand. Such understanding comes to us more naturally than one might think, so intuitive is it. Just as, in spinning a radio dial to select a station, the merest instant of music is enough to tell us which is a classical station, which rock, which country and western, so in interior design, a glimpse of a cornice profile or a table leg will be enough

**Sometimes a blunt contrast with the context is preferable to imitation. In his 1959 renovation for New York University of Horace Trumbauer's 1912 James B. Duke house, Robert Venturi placed new bookshelf supports free of the existing shell "to consider the new elements furniture rather than architecture" and thereby "separate the joint between the old and new layers."** *(Photograph: Leni Iselin, courtesy Venturi, Rauch & Scott Brown)*

to impart a sense of character of the whole wall or whole table. At least, this will be the case if the details are properly in consonance with the spirit of the whole.

Let us look at a few details—balusters, to begin with, also sometimes called banisters. The baluster is a device unknown to the classical world, yet much in use during the classical Renaissance both in stone (outside and inside) and later in wood (inside only). Generally circular in plan, it is characterized in elevation by curved swellings. Some are symmetrical, their top halves mirroring their bottom halves; others are asymmetrical, this second type probably first used by Michelangelo on the Campidoglio.

In his book on Palladio, architectural historian Rudolf Wittkower devotes a whole essay to that architect's baluster vocabulary. "Looking at the Palazzo Iseppo da Porto," he says, "it is impossible to imagine the balconies of the *piano nobile* with a solid parapet instead of the balustrades. The balusters have a specific function, both vertically and horizontally. They introduce a small-scale motif which is light and airy above the ashlar . . . of the ground floor, and in accenting the series of bays on the *piano nobile* they constitute an element which is part of a vaster and more complicated rhythmic arrangement. These balusters are quite plain and not too close to one another: Palladio is clearly interested in the free-play of air between these three-dimensional and symmetrical forms, and not in a complex and heavy motif, which would have been out of keeping with the nature of the composition."

Within the restricted vocabulary of sixteenth-century Italian balusters, there was a great variety of expression. The first four shown here are all by Palladio and all in Vicenza; from left to right, they are from the Palazzo Iseppo da Porto, the Palazzo Valmarana-Braga, the Palazzo Porto Barbaran, and the Basilica. The fifth example, by Vignola, is from the Villa Farnese, Caprarola, and the sixth is from Sansovino's Loggetta of the Campanile of San Marco, Venice. *(After Wittkower,* Palladio and Palladianism*)*

Wittkower noted many variations in baluster shape and in the junctions between parts and classified them as follows: first, the shape of the bulbs (either slender or heavy); second, the forms of the abacus at the top of the baluster and the base below (either a slender ring, a cushion shape, a combination ring and cushion, or a form similar to the ovolo of the Tuscan Doric order); third, the junction between two bulbs (either concave, convex, a combination of the two or a rectangular block); fourth, the spacing between one baluster and the next. This last variation is generally closely related to the first, slender balusters almost always being widely spaced and thick balusters being set close together, so that the characteristics of delicacy or of strength properly augment each other.

Wittkower illustrates his essay with a comparison of Renaissance balusters by Palladio and others, a few of which are shown here, and relates different types to different phases of the Renaissance and to different stages of Palladio's career, identifying various shapes as simple, enriched, massive or dynamic. The whole detailed analysis is of interest only to a specialist, the reader may complain, but the interior designer who may design a balustrade needs to *be* such a specialist, not necessarily in attributing baluster shapes to specific designers or periods, but at least in attributing to baluster shapes their individual characters.

Varied as the shapes of balusters may be, they constitute but a tiny portion of the large vocabulary of shapes and materials that the

Further variations on sixteenth-century stone balusters. From left to right: by Raphael from the Palazzo Pandolfini, Florence; by Michelangelo from the Palazzo Farnese, Rome; by Bramante from the Tempietto, San Pietro in Montorio, Rome; by Vignola from the Villa Giulia, Rome; by Sansovino from the Libreria Vecchia, Venice; and by Sanmicheli from the Palazzo della Torre, Verona. *(After Wittkower, Palladio and Palladianism)*

Nineteenth-century balusters in bronze, supporting the handrails of the stair hall in Josef Kornhäusel's Klosterneuberg Monastery.

The handrail at its most minimal: merely a coil of steel at Arne Jacobsen's 1955 Jespersen office building in Copenhagen. *(Photograph: author)*

designer can use for supporting railings. Ropes and wires, metal and glass and plastics in many configurations provide the designer with a veritable playground of possibilities, and there is no limit to future invention. Such a range is typical of many aspects of the designer's work; faced with so many opportunities, any interior design must be guided by a certain goal—a clear vision of what is to be expressed—if it is to speak to its users without ambiguity or muddle.

**Freed from the tradition of balusters, angled steel bars support the railings of Steven Holl's Pace Collection shop, New York.** *(Photograph: Paul Warchol)*

The glorious pine balustrade of the late-seventeenth-century Great Staircase, Sudbury Hall, Derbyshire, carved by Edward Pierce. Ceiling plaster work is by James Pettifer, and other carving in the house is by the famous Grinling Gibbons. *(Photograph: A. F. Kersting, London)*

For an example more portable and therefore less architectural, we might study Breuer's 1928 cantilevered Cesca chair, perhaps the most imitated furniture design of its century. Versions other than the original design can be identified because cheaper copies substitute machine caning for hand caning or omit some other subtle but important refinements. To consider only the steel tubing, there are two details that characterize the authentic Cesca. One is the lack of joints or welds in the tubing. Whereas Breuer emphasized the continuous sweep of his structural frame by specifying a single length of steel, imitations often offer instead the economies of a number of short pieces of tubing.

Marcel Breuer's 1928 Cesca chair: Thoughtful details distinguish the original from its many imitations.

Another tubing variation in later imitations is that the floor stretchers lie perfectly flat against the floor, whereas these members in the Breuer design are very slightly bowed. At first thought, we might assume the flat tube to be preferable, being straighter, more simply geometric, and more appropriately mechanistic, as well as easier to produce. But any irregularity in the tubing—or, more likely, in the flooring—will cause the flat-based chair to rock or shift; only a perfect alignment between tube and floor, for the whole length of the tube, will provide stability. The slightly arched base that Breuer designed, however, rests on only two end points; it will be steady despite any imperfections or rough spots on the floor between those points. As soon as we understand this functional difference, we see the bowed tube as the superior detail.

The number of choices available to the designer in detailing an installation may become even more apparent if we consider what may be the most simple of examples, the joint pattern in a field of identical units such as ceramic tile (or vinyl tile or carpet tile or panels of cork or needlework, leather or marble). To limit the possibilities, let us consider the cases in which the basic unit is square. In covering a flat, two-dimensional surface, the most obvious arrangement is this one, treating both horizontal and vertical directions as equally important:

By staggering the vertical joints only, we can produce an effect of stacked horizontal layers, a pattern similar to those used for masonry walls built up course by course, a pattern, therefore, suggesting stability:

And by turning this pattern 90 degrees, we can produce a pattern of continuous vertical stripes and parallel ladders of horizontal joints, emphasizing the vertical direction:

These are the two simplest joint patterns and the only ones we will consider further. Of a whole range of more dynamic patterns, emphasizing angular movement, we illustrate only one:

Returning to our two simplest patterns, let us see how they might be treated on two wall surfaces that meet at a right angle, as in a typical corner. The natural meeting of the first pattern is simply this:

But this visual simplicity is deceptive, for it cannot be achieved without two requirements: first, the designer must have considered the tile dimension and the wall dimension simultaneously (which means that this detail must have been decided at an early stage of the planning); and second, the designer must exercise control over the installation. Careless, unsupervised workmanship will inevitably produce columns of cut, partial tile in corners, no matter how careful the designer's planning.

The pattern with continuous vertical stripes has only one obvious corner condition:

The pattern with continuous horizontal stripes, however, may turn the corner in two ways, both of which require the use of half-

units. In the first, the second wall is treated as a mirror image of the first, making the corner an important feature:

In the second, the alternations of vertical joints continue uninterrupted, emphasizing the continuity of the pattern and making the corner seem less eventful:

In addition, although it may be difficult to think of applications where they would be appropriate, there are possibilities of combining one basic pattern on one wall and another on the other:

Or of staggering the same pattern by half a tile when the corner is turned:

When three planes come together at right angles, as when two tiled walls and a tiled floor meet, the possibilities proliferate. The most straightforward pattern, with uninterrupted joints in both directions, marches equably along, of course, over all three sufaces. As before, this simple effect will not be accomplished without care in both planning and execution, but this effort will be rewarded with an effect of order and equipoise:

But the patterns with unidirectional stripes will have to make a choice, the following solution, for example, relating the floor more closely to the left wall than to the right wall:

Other possibilities are:

Then there are pattern combinations that treat one wall differently from the other surfaces or that treat the floor differently from the walls:

Beyond these, there exists a number of combinations that use a base or border of cut tiles:

But these begin to take us beyond our self-imposed limits and suggest the whole new realm of effects possible if we introduce tiles in different sizes, different textures or different colors.

The point of this exercise is not to present patterns that are already common knowledge, but to suggest that each of these patterns is expressive in some degree about the relationships between planes and their relative importance in a room. The designer's choice is not an arbitrary one.

And this choice must be exercised throughout an interior. In the matter of seating upholstery, for example, the designer must choose not only a fabric material and pattern and color, but also the manner in which the upholstery is applied: it can be stretched flat across the

Details can trace potential contacts between objects. The steel circle inset flush with a wood floor in the Charivari Sport shop, New York, makes the path of the pivoting stool both durable and visible. The designer is **Toshiko Mori.** *(Photograph: Mark Darley)*

seat; it can be held down to the seat cushion with simple buttoning or with pleated tufting; if the latter, the designer can choose among diamond tufting, biscuit tufting, bun tufting, star tufting, or some untraditional pattern. Then there is the question of whether the tufts are to

Details can also be eloquent expressions of potential contact with the human body. A stair by George Ranalli, for example, faces Sheetrock treads and risers with birch plywood edged in brass, but only for the width where feet are likely to touch. *(Photograph: George Ranalli)*

Similarly, a steel door lever by Alvar Aalto is wrapped with leather where hands are expected to grasp it.

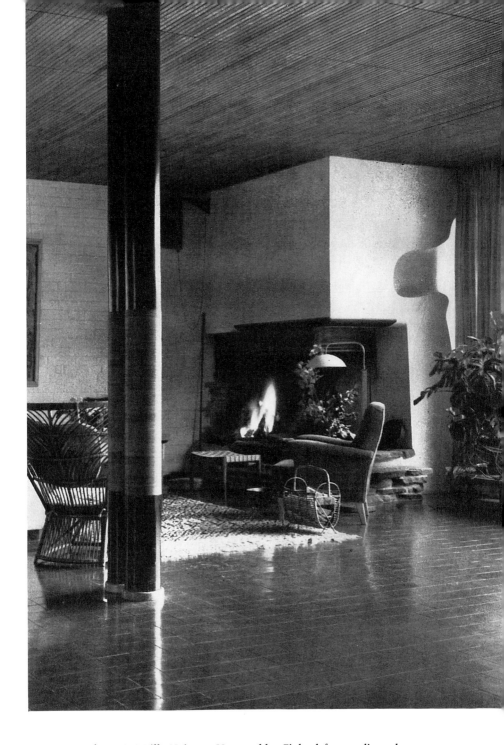

In Aalto's 1939 Villa Mairea at Noormarkku, Finland, freestanding columns in the living room are leather-wrapped for the part of their height where occupants may brush against them.

be held, as in the eighteenth century, by a bunch of silk or linen threads or, as in later fashions, by buttons. If the latter, then are the buttons to be covered in matching or in contrasting fabric? Or should they be brass?

These decisions are to be based, as we have said, on the meanings conveyed by details and on those meanings' consonance with the designer's overall scheme. But how can these meanings be known? They can never be known so exactly that they can be put into words, and we must not expect to find a verbal equivalent for a baseboard profile or a fringe detail or an air supply grille or an elevator call button, any more than we would expect to find a verbal equivalent for a Klee painting or a Mozart symphony.

We do not have to put these things into words, nor do we have to understand the mechanisms of how we perceive them and how our perceptions then result in reactions of pleasure or displeasure. There are questions, of undoubted interest to designers, about the working relationships between our retinas and our minds and about how much our reactions are based on our common biological dispositions and how much on our personal cultural training, but we do not have to resolve their answers in order to do our work well. We need merely be aware of design elements and the responses they evoke.

Architecture and interior design are two aspects of a singular art form—three-dimensional and habitable—that is untranslatable into any other. Its meanings can be learned only on their own terms, through discriminating looking and clear thinking, by each designer. With experience, the meanings of interiors and of all their contributory details are read as easily as we read the facial expressions of our friends or even, with less accuracy, of strangers.

# CONCLUSION:
# THE PRIMACY OF
# THE CONCEPT

R ALPH CAPLAN, in a delightful book called *By Design*, tells of a woman who introduced herself as a conceptual designer. "What does that mean?" he asked her. "I can't draw," she explained.

She may have been less handicapped than we suppose, for, useful as rough sketches are during the design process, she was saved at least from our most frequent design blunder, the production of drawings before we have produced an idea worth drawing. The drafting table is not a Ouija board, where we can expect the automatic appearance of messages from beyond; the messages expressed there come only from within. The concept that guides our pencil and that later will guide our eye in equipment, furniture and fabric selection is itself guided by such practical considerations as the functions to be served, the space to be used and the budget to be met. It is also guided by a less tangible consideration, the determination of a distinctive and appropriate personality for each job.

François Truffaut once praised the dependable standardization of American motels because, he said, one does not get *a* room, one gets *the* room. Most of us, however, are depressed, rather than cheered, by the endless replication of one guest room design or one office or one cubicle. We do not like our room to be identical to a hundred others

in the same building or to the one we occupied last week in another city. What interests us is diversity and particularity.

The designer can easily offer particularity (indeed, can hardly avoid it) when working for a known client with known needs and tastes. The design process will always be conscious of the client. Only in magazine illustrations are designs uninhabited, a practice that has been much criticized. (Italian editor and critic Bruno Zevi complained that structures in such photographs "appear to be little more than dead-looking mineral formations left standing after the destruction of the human race, for whom, however, those spaces and chairs were obviously intended.") Yet an unpeopled photograph is not the same as an unpeopled room; in the former, the absence of people, opaque as they inevitably are, lets us see the designer's work more clearly. Further, the illustrated room's emptiness is an invitation, allowing us as voyeurs an easier projection of ourselves into the space. But it is a perilous situation if ever for a moment a room is empty in its designer's imagination. Like the sound of the tree falling unheard in the forest, the quality of the uninhabited interior is of no consequence.

And how is the designer to apprehend the person whose presence gives consequence to an interior? The designer must be attuned to that person's tastes, habits, mental sensibilities and psychological susceptibilities, of course; but the designer must not forget the more obvious fact that the person also has a body.

We are accustomed to thinking of the body as the instrument of an art form only when engaged in special activities—ballet, gymnastics, pantomime, parades. But the body is also the key instrument in the art form of interior design. This three-dimensional bulk, with all its weight, its size, its heat, its sensing devices, its peculiar ways of moving and ways of folding, is ever-present when an interior is being used. It is not only a shell enclosing mental processes; the body is also the major physical reference by which those mental processes judge their surroundings. Alfred North Whitehead has spoken of the ever-present "withness" of the body and has written, in *Process and Reality*, that a "traveler, who has lost his way, should not ask Where am I? What he really wants to know is, Where are the other places? He has got his own body, but he has lost *them*."

But the nature of the human body is, after all, roughly the same for all of us. How can the quality of particularity be produced when designing for an unknown tenant, shopper, diner or computer operator? For these cases, individual character must be derived from local situations and, as always, from the designer's own insights and views.

This last factor is a critical one. Just as the success of any design will be limited by the wisdom of the concept it follows, the wisdom of any concept is limited by the vision and knowledge of the designer who conceives it. Before we presume to furnish our clients' rooms, to echo Thoreau, we must furnish our minds. The amount of technical knowledge needed by a designer continues to proliferate. More is needed as well: for fluency in what is, after all, a visual language, the designer will need a superior degree of visual literacy, reading easily the subtleties with which plans, rooms, furniture and ornament all speak to us. And still more is needed: the designer needs to care deeply for a design's users, even when those users are anonymous, and for a design's effects. As George Nelson put it, "The humane environment is not a slogan; it is a mystery which can only be penetrated by humane people."

Because the element of personality is such an important part of a design concept, that concept can never be wholly predicted or calculated. Being visual, it cannot easily be expressed in words. Being conceived in the designer's mind's eye, it cannot always be perfectly translated into tangible form.

T. S. Eliot, in his 1919 essay on *Hamlet*, described a similar problem in literature. "The only way of expressing emotion in the form of art," he said, "is by finding an 'objective correlative'; in other words, a set of objects, a situation, chain of events which shall be the formula of that *particular* emotion; such that when the external facts, which must terminate in sensory experience, are given, the emotion is immediately evoked." In Eliot's opinion, Lady Macbeth's sleepwalking scene matched her emotions very closely with words, but in *Hamlet* there was a discrepancy between Hamlet's "state of mind which is inexpressible" and Hamlet's words. An interior designer's finished product has the same duty as a playwright's words: it must be the physical manifestation of the artist's concept, including all of that concept's emotional aspects.

These aspects, which make interior design so subjective and so intimate, so immune to the calculations of science, so special to a singular circumstance and therefore so often ephemeral, also distinguish it from its more durable sister art of architecture. Our habitations and the other environments we make are "evidence," Eudora Welty has written, "evidence that we have lived, are alive now; . . . evidence some day that we were alive once, evidence against the arguments of time and the tricks of history." If, among these habitations, architecture is "a monument to the eternal, commemorating

both the absence and presence of man," as Raimund Abraham has said, then interior design is something less grandiose but something considerably more human, a monument not to the eternal but to the transient, a celebration of a very particular time, place and situation, commemorating the presence not of man but of specific men and women.

Interior design, being within architecture, is necessarily less big than architecture, but not necessarily less deep. In a 1933 speech dedicating a house in Potsdam, theologian Paul Tillich noted, "Philosophy does not have to do, as is often thought, with the general, abstract, otherwordly. . . . It is, rather, the interpretation of the closest, the concrete, the everyday. For in the proximate, the daily, the apparently small, there is hidden . . . the metaphysical; the here-and-now is the place where meaning is disclosed, where our existence must find interpretation, if it can find an interpretation at all. That is what dwelling, or the space of dwelling, is: something proximate, daily, apparently small over against great things." And more than twenty years later, writing in *Architectural Forum*, he continued by saying that "what must be done first of all in building is to single out from the infinite space, into which we are thrown in our nakedness, a piece of finite space that protects us against the infinite."

Faced, since our childhoods, with a sense of the world's otherness, an awareness of discontinuity between ourselves and everything else in the universe, we long for a healing wholeness, Tillich's imagined protection against the infinite. We find this in our interiors. These intimate spaces are the screens on which we project our inner visions; they are the shells from within which we view the world beyond, their windows our eyes, their walls and ceilings our security, their furniture and decor our convictions and our fancies. They are our most personal art.

# BIBLIOGRAPHY

There are as many ways of writing about interior design as there are aspects of practicing it. One can write in advocacy of a particular style; one can write the history of a succession of styles; one can examine particular installation types, their functional demands and their possible solutions; one can explain techniques contributory to interior design, such as stenciling, fabric weaving and wood finishing; one can present available products; one can give advice on profitable business practices.

The books and articles listed below deal not at all or only coincidentally with the subjects listed above. Instead, they deal at least in part with interior design viewed philosophically. Works quoted extensively in the text are included, as are some that, while not directly quoted, have been helpful to the author and may be helpful to the reader who wants to pursue the direction this book has suggested. There is much for us to learn.

Abercrombie, Stanley, "Aalto's 1949 Poetry Room at Harvard," *Journal of the Society of Architectural Historians,* 38, no. 2 (May 1979).

———, *Architecture as Art* (New York: Harper & Row, 1986).

———, "The Plan as Determinant of Movement," *AIA Journal,* October 1982, pp. 72–77.

Abraham, Raimund, "Negation and Reconciliation," in *Perspecta 19,* ed. Brian Healy (Cambridge, Mass.: MIT Press, 1982).

Adams, William Howard, *Jefferson's Monticello* (New York: Abbeville Press, 1983).

Andrew, David S., *Louis Sullivan and the Polemics of Modern Architecture: The Present Against the Past* (Urbana: University of Illinois Press, 1985).

Arnheim, Rudolf, *The Power of the Center: A Study of Composition in the Visual Arts, the New Version* (Berkeley and Los Angeles: University of California Press, 1988).

Aronson, Joseph, *The Book of Furniture and Decoration: Period and Modern* (New York: Crown, 1941).

Auden, W. H., *About the House* (New York: Random House, 1965).

Bachelard, Gaston, *The Poetics of Space*, trans. Maria Jolas (Boston: Beacon Press, 1969).

Benedikt, Michael, *For an Architecture of Reality* (New York: Lumen Books, 1987).

Blake, Peter, *The Master Builders* (New York: Knopf, 1964).

Blake, Peter, and Jane Thompson, "A Very Significant Chair," in *Architecture Plus*, May 1973.

Bloomer, Kent C., and Charles W. Moore, *Body, Memory and Architecture* (New Haven, Conn.: Yale University Press, 1977).

Braudel, Fernand, *The Structures of Everyday Life*, vol. I of *Civilization and Capitalism, 15th–18th Century*, trans. Siân Reynolds (New York: Harper & Row, 1985).

Burgess, Anthony, *On Going to Bed* (New York: Abbeville Press, 1982).

Calloway, Stephen, "Taste, Fashion and the Way Rooms Change," in his *Twentieth-Century Decoration* (New York: Rizzoli, 1988).

Caplan, Ralph, *By Design* (New York: St. Martin's Press, 1982).

Casson, Hugh, *Inscape: The Design of Interiors* (London: The Architectural Press, 1968).

Christie, Archibald H., *Pattern Design: An Introduction to the Study of Formal Ornament* (New York: Dover, 1969). First published as *Traditional Methods of Pattern Designing* (Oxford: Clarendon Press, 1910).

Cook, Peter, *Architecture: Action and Plan* (New York: Reinhold, 1967).

Cooke, Edward S., Jr., ed., *Upholstery in America and Europe from the Seventeenth Century to World War I* (New York: Norton, 1987).

Danto, Arthur C., "The Seat of the Soul," in *397 Chairs* (New York: Abrams, 1988).

Davenport, Guy, *The Geography of the Imagination* (San Francisco: North Point Press, 1981).

De Long, David G., *Bruce Goff: Toward Absolute Architecture* (New York; Cambridge, Mass.; and London: The Architectural History Foundation and MIT Press, 1988).

De Zurko, Edward Robert, *Origins of Functionalist Theory* (New York: Columbia University Press, 1957).

Dormer, Peter, "The Ideal World of Vermeer's *Little Lacemaker*," in John Thackera, ed., *Design after Modernism* (New York: Thames & Hudson, 1988).

Dorner, Alexander, *The Way Beyond Art* (New York: New York University Press, 1958).

Dubos, René, *Man, Medicine and Environment* (London: Pall Mall Press, 1968).

———, *So Human an Animal* (New York: Scribners, 1968).

Edwards, Trystan, *Good and Bad Manners in Architecture* (London: Tiranti, 1945).

Eidson, Patricia L., "Critical Thinking: Elements of Interior Design Theory," in *Journal of Interior Design Education and Research*, Fall 1986.

Evans, Joan, *Nature in Design* (London: Oxford University Press, 1933).

———, *Pattern: A Study of Ornament in Western Europe from 1180 to 1900* (London: Oxford University Press, 1931).

———, *Style in Ornament* (London: Oxford University Press, 1950).

Ferebee, Ann, *A History of Design from the Victorian Era to the Present* (New York: Van Nostrand Reinhold, 1970).

Fitch, James Marston, "The Aesthetics of Function," in *Annals of The New York Academy of Science*, vol. 128, Sept. 27, 1965.

Frank, Edward, "On the Development of Modern Rationalist Space in Architecture," unpublished manuscript, 1988.

Fry, Roger, *Vision and Design* (New York: Peter Smith, 1947).

Giedion, Sigfried, *Architecture and the Phenomena of Transition: The Three Space Conceptions in Architecture* (Cambridge, Mass.: Harvard University Press, 1971).

———, *Mechanization Takes Command* (New York: Norton, 1969).

———, *Space, Time and Architecture*, fifth ed. (Cambridge, Mass.: Harvard University Press, 1967).

"Gold Bar," *The New Yorker*, August 1, 1988.

Gombrich, E. H., *The Sense of Order: A Study in the Psychology of Decorative Art* (Ithaca, N.Y.: Cornell University Press, 1984).

———, "Visual Metaphors of Value in Art," in his *Meditations on a Hobby Horse* (London: Phaidon, 1963). Originally written in 1952 for a New York symposium, *Symbols and Values*.

Grier, Katherine C., *Culture & Comfort: People, Parlors and Upholstery 1850–1930* (Rochester, N.Y.: The Strong Museum, 1988).

Gutman, Robert, ed., *People and Buildings* (New York: Basic Books, 1972).

Hall, E. T., "Art, Space, and the Human Experience," in Gyorgy Kepes, ed., *Arts of the Environment* (New York: Braziller, 1972).

———, *Beyond Culture* (Garden City, N.Y.: Anchor/Doubleday, 1977).

———, *The Hidden Dimension* (Garden City, N.Y.: Doubleday, 1966).

Harbison, Robert, *Eccentric Spaces* (New York: Knopf, 1977).

Hazard, John N., "Furniture Arrangement as a Symbol of Judicial Roles," in Robert Gutman, ed., *People and Buildings* (New York: Basic Books, 1972).

Heidegger, Martin, *Poetry, Language, Thought*, trans. Albert Hofstadter (New York: Harper & Row, 1975).

Hein, Piet, "Of Order and Disorder, Science and Art and the Solving of Problems," *Architectural Forum*, December 1967.

Hillier, Bevis, *The World of Art Deco* (New York: Dutton, 1971).

Hitchcock, Henry-Russell, and Philip Johnson, *The International Style: Architecture Since 1922* (New York: Norton, 1932).

Hudnut, Joseph, *Architecture and the Spirit of Man* (Cambridge, Mass.: Harvard University Press, 1949).

Jones, Owen, *The Grammar of Ornament* (New York: Van Nostrand Reinhold, 1982). First published in London in 1856.

Kennedy, Robert Woods, *The House and the Art of Its Design* (New York: Reinhold, 1953).

Kepes, Gyorgy, ed., *Arts of the Environment* (New York: Braziller, 1972).

Krier, Rob, *Architectural Composition* (New York: Rizzoli, 1988).

Kron, Joan, *Home-Psych* (New York: Clarkson N. Potter, 1983).

Kubler, George, *The Shape of Time* (New Haven, Conn.: Yale University Press, 1962).

Lang, Jon, *Creating Architectural Theory: The Role of the Behavioral Sciences in Environmental Design* (New York: Van Nostrand Reinhold, 1987).

Laver, James, *Style in Costume* (London: Oxford University Press, 1949).

Lears, T. J. Jackson, "Infinite Riches in a Little Room: The Interior Scenes of Modernist Culture," in *Modulus 18* (Charlottesville: The University of Virginia School of Architecture, 1987).

Le Corbusier, *The Decorative Art of Today*, trans. James Dunnett (Cambridge, Mass.: MIT Press, 1987). First published as *L'Art décoratif d'aujourd'hui* (Paris: Éditions Crès, 1925).

———, *Towards a New Architecture*, trans. Frederick Etchells (London: The Architectural Press, 1946). First published as *Vers une architecture* (Paris: Éditions Crès, 1923).

Leitner, Bernhard, *The Architecture of Ludwig Wittgenstein: A Documentation* (New York: New York University Press, 1976).

Lethaby, W. R., *Architecture, Nature and Magic* (New York: Braziller, 1956).

———, "Housing and Furnishing," in his *Form in Civilization* (London: Oxford University Press, 1957).

Loustau, Jennifer, "A Theoretical Base for Interior Design: A Review of Four Approaches from Related Fields," in *Journal of Interior Design Education and Research*, vol. 14, no. 1 (spring 1988).

Lucie-Smith, Edward, *Furniture: A Concise History* (especially the first chapter, "Meanings of Furniture") (London: Thames & Hudson, 1979).

Lym, Glenn Robert, *A Psychology of Building: How We Shape and Experience Our Structured Spaces* (Englewood Cliffs, N.J.: Prentice-Hall, 1980).

McClung, William Alexander, *The Architecture of Paradise* (Berkeley: University of California Press, 1983).

McLaughlin, Jack, *Jefferson and Monticello* (New York: Henry Holt, 1988).

Marc, Olivier, *Psychology of the House* (London: Thames & Hudson, 1977).

Marti, Manuel, Jr., *No Place to Hide: Crisis and Future of American Habitats* (Westport, Conn., and London: Greenwood Press, 1984).

Mehrabian, Albert, *Public Places and Private Spaces* (New York: Basic Books, 1976).

Miller, Stuart, and Judith K. Schlitt, *Interior Space: Design Concepts for Personal Needs* (New York: Praeger, 1985).

Moore, Charles, Gerald Allen, and Donlyn Lyndon, *The Place of Houses* (New York: Holt, Rinehart and Winston, 1974).

Nelson, George, "The End of Architecture," in *Architecture Plus*, vol. 1, no. 3 (April 1973).

Norberg-Schulz, Christian, *Architecture: Meaning and Place* (New York: Rizzoli, 1988).

———, *The Concept of Dwelling* (New York: Rizzoli, 1985).

O'Doherty, Brian, *Inside the White Cube: The Ideology of the Gallery Space* (San Francisco: Lapis, 1986).

Papanek, Victor, *Design for Human Scale* (New York: Van Nostrand Reinhold, 1983).

Pater, Walter, *Marius the Epicurean: His Sensations and Ideas* (Oxford and New York: Oxford University Press, 1986). First published in 1885.

Pile, John, *Open Office Planning* (New York: Whitney Library of Design, 1978).

Poe, Edgar Allan, "The Philosophy of Furniture," in *The Unabridged Edgar Allan Poe* (Philadelphia: Running Press, 1983).

Post, Emily, *The Personality of a House: The Blue Book of Home Design and Decoration* (New York: Funk & Wagnalls, 1930).

Praz, Mario, interview, *Abitare*, September 1981.

———, *The House of Life*, translated by Angus Davidson (New York: Oxford University Press, 1964). First published as *La casa della vita* (Milan: Mondadori, 1958).

———, *An Illustrated History of Interior Decoration*, translated by William Weaver (London: Thames & Hudson, 1982). First published as *La filosofia dell'arredamento* (Milan: Longanesi, 1964).

———, *Mnemosyne: The Parallel Between Literature and the Visual Arts* (Princeton, N.J.: Princeton University Press, 1974).

Quantrill, Malcolm, *The Environmental Memory: Man and Architecture in the Landscape of Ideas* (New York: Schocken, 1987).

Ranalli, George, with Michael Sorkin and Anthony Vidler, *George Ranalli: Buildings and Projects* (Princeton, N.J.: Princeton University Press, 1988).

Rasmussen, Steen Eiler, *Experiencing Architecture* (New York: John Wiley & Sons, 1959).

Rossbach, Sarah, *Interior Design with Feng Shui* (New York: Dutton, 1987).

Rowe, Peter G., *Design Thinking* (Cambridge, Mass.: MIT Press, 1987).

Rudofsky, Bernard, *Behind the Picture Window* (New York: Oxford University Press, 1955).

———, *Now I Lay Me Down to Eat* (Garden City, N.Y.: Anchor/Doubleday, 1980.)

Ruskin, John, *Modern Painters*, vol. III, part 4, ed. David Barrie (New York: Knopf, 1987).

Rykwert, Joseph, "The Sitting Position—A Question of Method," in George Baird and Charles Jencks, eds., *Meaning in Architecture* (London: Barrie and Jenkins, 1969).

Santayana, George, *Reason and Art* (New York: Collier, 1962).

———, *The Sense of Beauty* (New York: Dover, 1955).

Schwarz, Rudolf, *The Church Incarnate,* trans. Cynthia Harris (Chicago: Henry Regnery, 1958). First published as *Vom Bay Der Kirche* (Heidelberg: Verlag Lambert Schneider, 1938).

Scully, Vincent, *New World Visions of Household Gods and Sacred Places* (Boston: New York Graphic Society Books/Little, Brown, 1988).

Segrest, Robert, "The Perimeter Projects: Notes for Design," in *Assemblage,* no. 1 (Cambridge, Mass.: MIT Press, 1986).

Shapiro, Meyer, "On Perfection, Coherence, and Unity of Form and Content," in Sidney Hook, ed., *Art and Philosophy* (New York: New York University Press, 1966).

Smith, C. Ray, *Interior Design in 20th-Century America: A History* (New York: Harper & Row, 1987).

Sommer, Robert, *Tight Spaces: Hard Architecture and How to Humanize It* (Englewood Cliffs, N.J.: Prentice-Hall, 1974).

Stafford, Maureen, and Dora Ware, *An Illustrated Dictionary of Ornament* (New York: St. Martin's Press, 1974).

Stein, Gertrude, *How to Write* (Craftsbury Common, Vt.: Sherry Urie, 1977). First published in France in 1931.

Stokes, Adrian, *The Image in Form,* ed. Richard Wollheim (New York: Harper & Row, 1972).

Sullivan, Louis, *The Autobiography of an Idea* (New York: Dover, 1956). First published in 1924.

Tate, Allen, *The Making of Interiors: An Introduction* (New York: Harper & Row, 1987).

Teyssot, Georges, "The Disease of the Domicile," in *Assemblage,* no. 6 (Cambridge, Mass.: MIT Press, 1988).

Thackara, John, *Design After Modernism* (London and New York: Thames & Hudson, 1988).

Thoreau, Henry David, *Walden* (New York: Signet, 1960). First published in 1854.

Thornton, Peter, *Authentic Decor: The Domestic Interior 1620–1920* (London: Viking, 1984).

Tillich, Paul, "Dwelling, Space, and Time," in John Dillenberger, ed., *Paul Tillich on Art and Architecture* (New York: Crossroad, 1987).

———, "Theology and Architecture," in Dillenberger, op. cit.

Troy, Nancy J., *The De Stijl Environment* (Cambridge, Mass.: MIT Press, 1983).

Tuan, Yi-fu, *Space and Place: The Perspective of Experience* (Minneapolis: University of Minnesota Press, 1977).

———, *Topophilia: A Study of Environmental Perception, Attitudes and Values* (Englewood Cliffs, N.J.: Prentice-Hall, 1974).

Veblen, Thorstein, *The Theory of the Leisure Class* (New York: Mentor, 1953). First published in 1899.

Venturi, Robert, *Complexity and Contradiction in Architecture* (New York: The Museum of Modern Art, 1966).

Wharton, Edith, and Ogden Codman, Jr., *The Decoration of Houses* (New York: Norton, 1978). First published by Scribner's, New York, 1902.

Williams, Tod, and Ricardo Scofidio, *Window, Room, Furniture* (New York: Rizzoli and The Cooper Union, 1981).

Wines, James, *De-Architecture* (New York: Rizzoli, 1987).

———, "The New Architecture—A Dialogue in the Mind," in *Architecture and Abstraction: The Pratt Journal of Architecture* (New York: Rizzoli, 1985).

Wittgenstein, Ludwig, *Culture and Value*, ed. G. H. Von Wright, trans. Peter Winch (Chicago: University of Chicago Press, 1984).

———, *Remarks on Color*, ed., G. E. M. Anscombe, trans. Linda L. McAlister and Margarete Schattle (Berkeley and Los Angeles: University of California Press, 1978).

Wittkower, Rudolf, *Palladio and Palladianism* (New York: Braziller, 1974).

Worringer, Wilhelm, *Form in Gothic*, ed. Herbert Read (New York: Schocken, 1964).

Wright, Frank Lloyd, *An Autobiography* (New York: Horizon, 1932).

———, "The Destruction of the Box," in Edgar Kaufmann, jr., and Ben Raeburn, eds., *Frank Lloyd Wright: Writings and Buildings* (New York: Horizon, 1960).

Yourcenar, Marguerite, *The Dark Brain of Piranesi* (New York: Farrar, Straus & Giroux, 1984).

Zevi, Bruno, *Architecture as Space* (New York: Horizon, 1957).

# Index